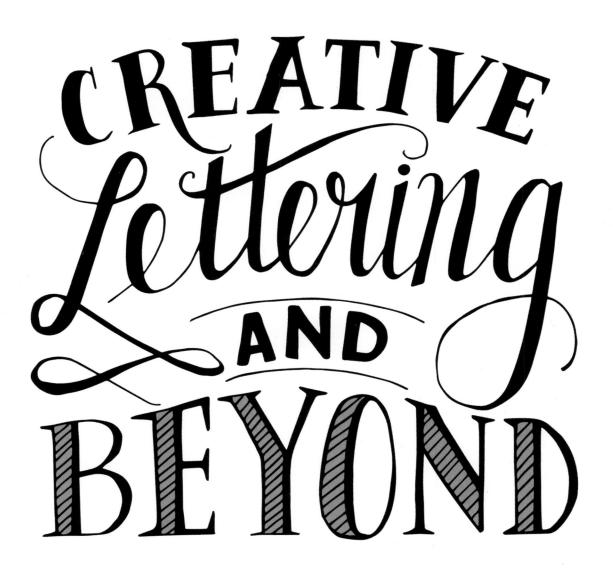

Gabri Joy Kirkendall, Laura Lavender, Julie Manwaring & Shauna Lynn Panczyszyn

Quarto is t Quarto duarto edu enthusiast www.quar

Quarto is the authority on a wide range of topics. Quarto educates, entertains, and enriches the lives of our readersenthusiasts and lovers of hands-on living. www.quartoknows.com

© 2014 Quarto Publishing Group USA Inc. Published by Walter Foster Publishing,

an imprint of The Quarto Group

All rights reserved. Walter Foster is a registered trademark.

Artwork on front cover by Valerie McKeehan. Artwork on back cover (middle left) and pages 4, 5, and 46–93 © 2014 Gabri Joy Kirkendall. Artwork on back cover (bottom left) and pages 132–143 © 2014 Julie Manwaring. Artwork on back cover (bottom middle) and pages 8–43 © 2014 Laura Lavender. Artwork on back cover (bottom right), inside front cover, and pages 98–129 © Shauna Lynn Panczyszyn. Photographs on pages 52, 53, 98, and 99 © Shutterstock.

All rights reserved. No part of this book may be reproduced in any form without written permission of the copyright owners. All images in this book have been reproduced with the knowledge and prior consent of the artists concerned, and no responsibility is accepted by producer, publisher, or printer for any infringement of copyright or otherwise, arising from the contents of this publication. Every effort has been made to ensure that credits accurately comply with information supplied. We apologize for any inaccuracies that may have occurred and will resolve inaccurate or missing information in a subsequent reprinting of the book.

Coatter Foster

6 Orchard Road, Suite 100 Lake Forest, CA 92630 quartoknows.com Visit our blogs at quartoknows.com

This book has been produced to aid the aspiring artist. Reproduction of work for study or finished art is permissible. Any art produced or photomechanically reproduced from this publication for commercial purposes is forbidden without written consent from the publisher, Walter Foster Publishing.

Printed in China 23

Table of Contents

Introduction
Nodern Calligraphy with Laura Lavender
Illustrated Lettering with Gabri Joy Kirkendall
Chalk Lettering with Shauna Lynn Panczyszyn
Lettering Crafts with Julie Manwaring
About the Artists 144

Introduction

FROM CREATIVE CALLIGRAPHY TO ILLUSTRATIVE ILLUMINATION, lettering is a beautiful way to write and draw words with just a pencil, a pen, chalk, or paint, you can turn 26 little letters into swoon-worthy works of art!

In *Creative Lettering and Beyond*, you'll find a variety of creative prompts and exercises and easy-to-follow, step-by-step projects that cover a range of styles and mediums, from pens, watercolor, and gouache to chalk, wood burning, and even using digital tools! Each project, prompt,

and exercise features simple instruction and beautiful images to inspire. With the guidance of the four talented artists featured in this book, you will learn how to turn your own hand lettering into works of art, stationery, gifts, and more.

In hand lettering, the rules of typography are meant to be broken. You can customize letters and words and push the boundaries, developing your own rules and methods as you go. So let your imagination run free. Your letters can be imaginative, whimsical, elegant, or quirky—the choice is yours! Like most art forms, lettering requires practice. Don't give up if your first letterforms don't come out the way you imagined. Just keep at it, and soon the curves, shapes, and forms will come naturally.

With the lettering projects in this book—and helpful artist tips throughout—you'll soon be on your way to developing and mastering your own unique style of lettering. So get your creative gears spinning...this is just the beginning!

How to Use This Book

THE PROMPTS, PROJECTS, AND EXERCISES IN THIS BOOK are designed to inspire you to create beautiful hand-lettered works of art, gifts, home décor, and more! You can find the supplies for all of the projects, prompts, and exercises at your local art & craft store or favorite art supplies retailer and hardware stores. This book is divided into four sections:

- Modern Calligraphy with Laura Lavender
- Illustrated Lettering with Gabri Joy Kirkendall
- Chalk Lettering with Shauna Lynn Panczyszyn
- Lettering Crafts with Julie Manwaring

In each section, you'll find helpful information about the tools and materials you can use to create gorgeous lettering in various mediums, as well as a series of prompts, exercises, and step-by-step projects to help bring your hand lettering to life. Along the way, you'll find helpful artist tips to encourage and inspire, as well as open practice pages throughout for you to try out techniques and sketch your own ideas.

Ready to get started? Turn the page to begin creating beautiful hand-lettered art!

Hodern Caligraphy

WITH LAURA LAVENDER

WELCOME! I LOVE CALLIGRAPHY, and I am so happy that you do too! This section of the book is all about having fun with the pointed pen in a modern way, with an eye on the history of the lettering style.

The word calligraphy comes from the Greek words *kallos*, "beauty," and *graph*, "writing." There is much satisfaction found in creating beautiful writing—the sound of the pen nib gliding across paper, the swirls of the letters, the flourishes, and of course, the usefulness of this skill in day-to-day life.

The calligraphy style in this section is what I like to call "modern vintage," which is how I refer to my own calligraphy style. In this style, the letterforms are based on old calligraphy styles but do not strictly adhere to the guidelines of traditional pointed pen calligraphy hands, such as Copperplate and Spencerian. The lettering in this section is inspired by masterful letterers of earlier times, but also is thoroughly modern and can be unique to you.

Unique to you? Yes! Learning calligraphy in this method will help you develop your own personal handwriting into an elegant calligraphy style that is yours and yours alone.

Let's get started, shall we?

Getting Started

BEFORE WE DIVE INTO THE ART OF LETTERING, it's important to go over the three basic steps of beautiful calligraphy: (1) Tools, (2) Techniques, and (3) Strokes.

Tools

The basic tools for the calligrapher are pen nibs, a pen holder, ink, and paper. Art supplies can be expensive, but be sure to select the highest quality of materials you can afford—you truly get what you pay for. Low-quality tools can be difficult to use. It's always a good idea to purchase a small quantity of a few different types of supplies to experiment with and find the ones that suit you best.

tines

Pen Nibs

For the kind of calligraphy we'll be exploring, a pointed pen nib is required. Pointed pen nibs are made from flexible metal and are sharply pointed. The pressure the calligrapher places on the nib causes the tines of the nib to spread, producing those lovely thin-to-thick swells we all love. Pointed pen nibs come in a wide variety of styles. Some are more pointed, some are very stiff, and some are very flexible. Be sure to purchase a few different types to see which styles you like best.

Pen Holder

I like to use an oblique pen holder for calligraphy, which holds the pen nib at an angle near the tip. An oblique pen holder is necessary for Spencerian- and Copperplatestyle calligraphy, which is written at a steeply slanted angle—up to 55 degrees! The position of the nib in the metal holder (called the flange) plays an important role in your writing. Experiment with the position of the nib as well as the angle of the pen, to see what works best for your writing style. If the pen nib is at the wrong angle, the point can scratch the paper, producing blobs and smears instead of graceful lines. Be ready for some splatters as you become accustomed to using pointed pen nibs. Just keep going!

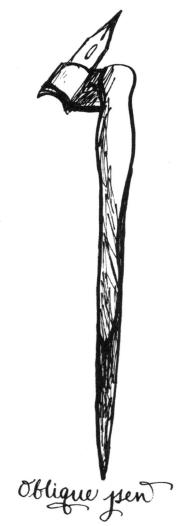

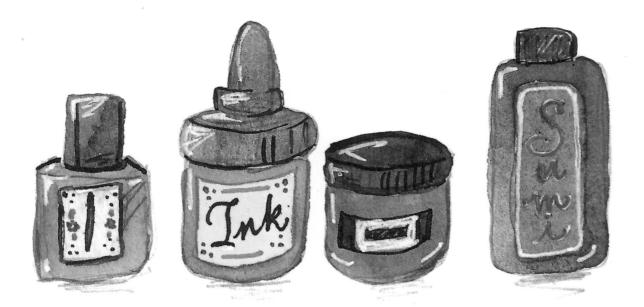

Ink

A calligrapher must have ink! You can find calligraphy ink at your local art & craft store. I recommend black ink because it tends to have the best texture. Most art stores carry many different types of beautiful inks; however, not all of them work well with a pointed pen. Try out several different kinds to find your favorites. Additionally, there are many other kinds of writing fluids that can be used with a pointed pen nib, but we will dive into those later! My favorite types of ink are sumi, walnut, and acrylic.

Paper

Paper choice is an important aspect of pointed pen calligraphy. The paper must be smooth; otherwise the fibers of the paper will get caught in the tines of the nib, and you will have an ink explosion on your hands (and everywhere else)! Most rough, handmade papers and thick, textured papers, while lovely, are not suitable for pointed pen work. Art supply stores typically carry several different types of paper. Be sure to choose a paper intended for calligraphy or illustration. As with all tools, purchase a small quantity of several different types of paper to see which ones you like best. My favorite paper choices are smooth bond paper; lightweight illustration paper; and smooth (hot-pressed), lightweight watercolor paper.

Finding Supplies

Some of the supplies mentioned here, especially pen nibs and pen holders, are specialty tools that may not always be available locally. If you can't find a tool at your local art supply store, there are a number of online retailers that carry these supplies, including John Neal Bookseller, Scribblers, and Paper & Ink Arts.

9

Techniques

Calligraphy with a pointed pen is all about pressure and angles. The pressure of the calligrapher's hand on the pen nib is what produces the desirable thick-and-thin lines of the letters. The angle at which the pen is held creates an elegant slant and gives shape to the letters.

Handling the Pen

The movement of the pen nib must always align with the slant of the letter being drawn. Creating beautiful, thick-andthin sections of letterforms is all about the amount of pressure you place on the nib. Since pointed pen nibs are flexible, applying more pressure causes the tines in the nib to spread, creating a thicker line. Therefore, apply less pressure for a thin line. ▲ Glide the pen nib gently in the direction of the split in the tines to reduce ink splatters across the page! Pay attention to how much pressure you apply to the pen, as well as how tightly you grip it. Your hand shouldn't hurt after a practice session of calligraphy. Hold the pen lightly, and apply gentle pressure.

Practicing Proper Posture

Posture is very important in calligraphy. I regularly check to make sure I am not hunched over my table. Take a moment every once in a while to check your posture. Below are some tips for proper posture:

- Keep your feet on the floor, your back straight, your arms and shoulders loose, and your head in line with your neck.
- Use a tabletop easel or a board propped against your table to keep your work at a 45-degree angle. This helps keep your back straight.
- Keep your hand gliding, not planted.

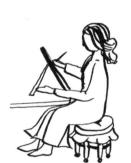

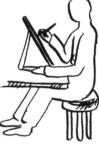

Yes!

No!

Using a Guard Sheet

Always place a piece of scrap paper under your hand—even when you're just practicing! The natural oils in your hand can affect ink flow and cause smudging and smearing. Try using a playing card or similar slippery-coated paper to help your hand glide as you work.

guara J sheet -ALWAYS/

Cleaning & Maintaining the Nib

It is important to regularly clean your pen nib as you work. Dirty nibs are susceptible to degrading, due to certain types of ink. They are also more likely to cause splattering and bleeding. Crisp lines and swells require a clean pen nib!

Clean your pen nib by swishing it in water every couple of sentences. Dry it on a lint-free towel. I keep a few old rags on my desk for this purpose.

Changing the Nib

Pen nibs don't last forever. Once your nib looks worn or the tines are bent or separated, it's time to replace it. Be sure to clean your new pen nib prior to use; some new nibs are coated with a material that maintains it until use but will inhibit ink flow.

Setting Up Your Workspace

Set up your work area so that the light source shines from the opposite side of your working arm to avoid casting shadows on your work. Place all your inks and tools to the side of your working arm to avoid drips and spills. If you are right-handed, set up your space as demonstrated here. If you are left-handed, reverse the setup.

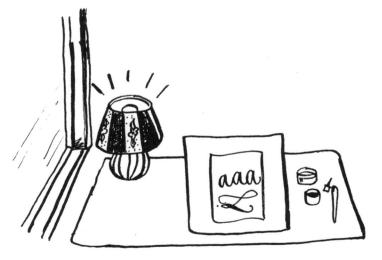

Strokes

The movement of the pen nib must align with the slant of the letters. Pulling the pen nib in an unnatural angle across the paper can result in splatters as the tines catch on the grain of the paper.

|///

▼ Check out this illustration of a small letterform being created. The circular shape of the letter "a" is drawn with the slit of the pen nib lining up with the slant of the letter. This technique results in pretty letters—not splatters.

Up and Down Strokes

As a general rule of thumb, put pressure on downward strokes and gently glide the pen on upward strokes.

つつつ

4U, U U

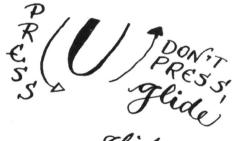

press, glide

Thick and Thin Strokes

Aim for smooth transitions when joining thick and thin strokes together. Practice drawing connecting circles to perfect this technique.

PRESS begin X DOQglide

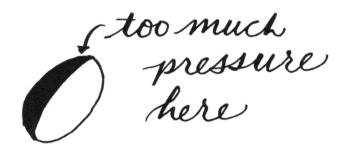

s not enough pressure

000000000 eleccelecce

Lettening Exercise

Practicing Strokes

Before you begin any prompts or projects in this section, take some time to practice fluid movements and joining strokes together. You may use the blank page opposite or practice on separate paper. Remember to maintain a comfortable grip on your pen and keep your practice sheet in front of you, not off to the side.

Keep the following in mind:

- Pay attention to your angles and how much pressure you apply to the pen.
- Aim to keep the slit in the pen nib in line with the angle of the letters.
- Generally, put pressure on downward strokes and gently glide on upward strokes.
- Keep your thin lines roughly the same size and your thick lines roughly the same size.
- Most of all, be loose and free—and have fun!

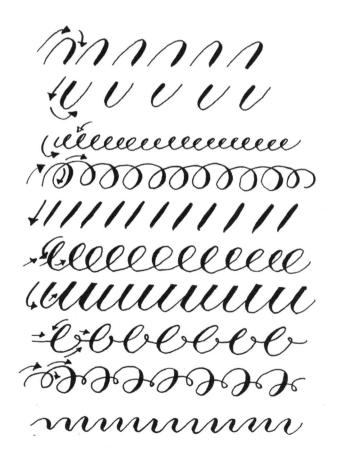

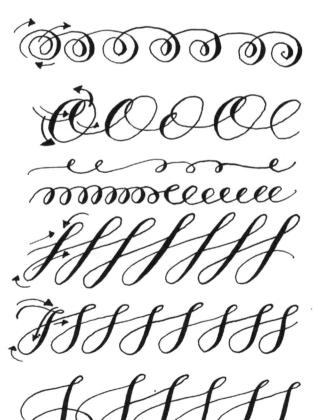

Creating Letters

NOW THAT YOU'VE PRACTICED SHAPES AND STROKES, we can dive into the fun part—the letters! We'll practice making *minuscules* (lowercase letters) and *majuscules* (capital letters) at a slant, giving them a formal look loosely based off the Copperplate/Engrosser's Script lettering style. Once you're familiar with that style, we'll work on more casual, upright scripts. Let's get started!

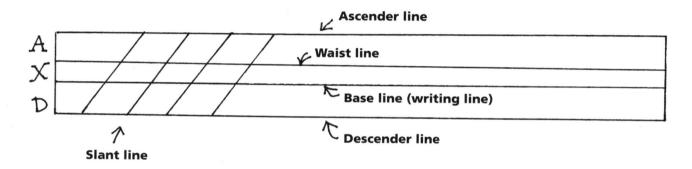

We'll use a lined writing sheet to create the letters. Each set of lines is divided into three sections. The middle section is where the letters sit. The ascenders on tall letters like "d" and "b" stretch up to the very top line. The descenders on letters like "p" and "y" reach to the very bottom line.

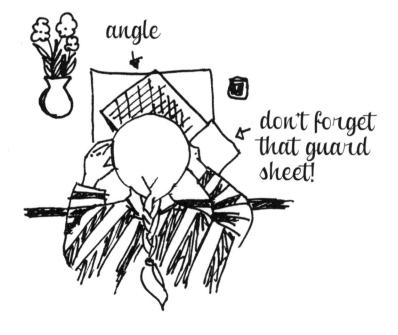

Slant Line

The slant line is the angle at which the letters are created. As discussed earlier, aim to keep the pen nib aligned with the slant line. Try to keep the slant line pointed roughly in your direction.

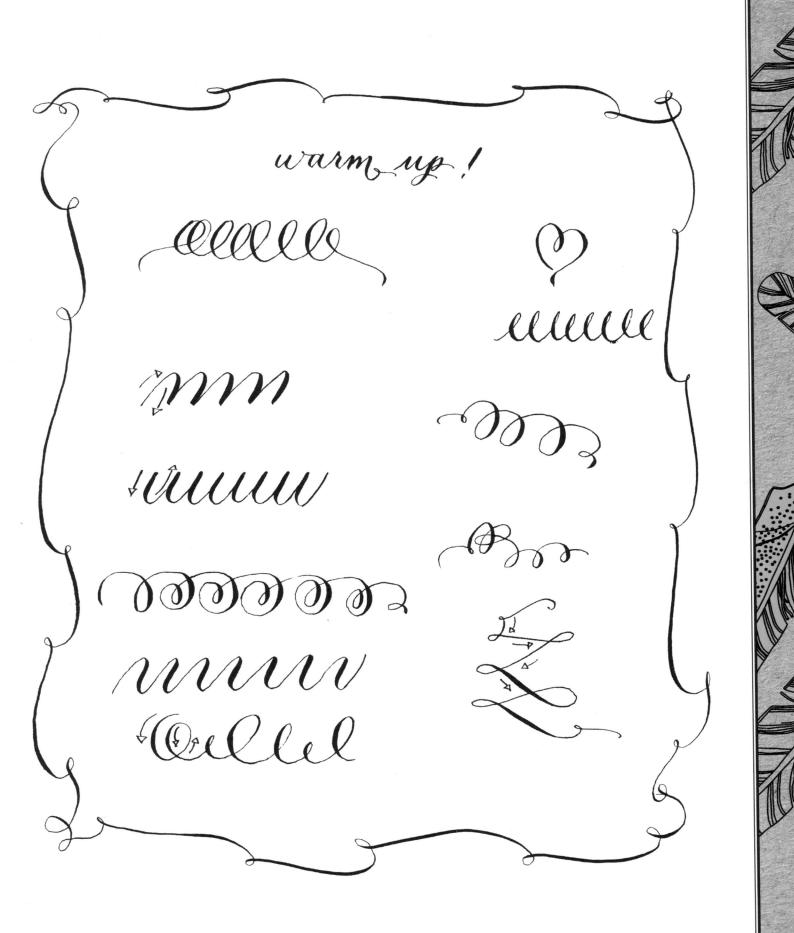

Minuscules

As you practice writing letters, strive to maintain similar-weighted strokes and a similar pattern of spacing between strokes so that like letters look almost identical. Aim for smooth curves—think of gentle, flowing movements.

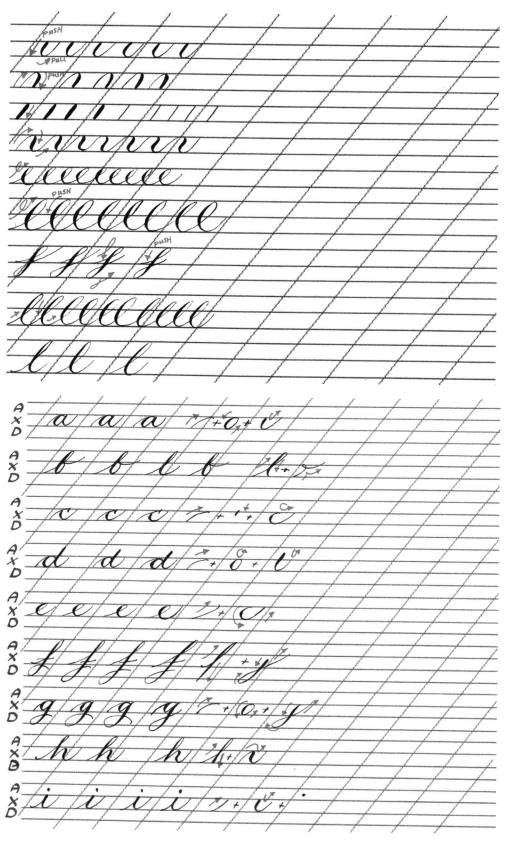

The arrows demonstrate the direction in which the pen should be pushed or pulled. Remember to push (gently) on the downstrokes, and pull on the upstrokes.

Strive to keep all of the thick lines the same width and all of the thin lines the same width for consistency. Look for ovals and circles in the letters and try to keep them about the same size.

18

AXD + , + AXD ,U AXD AXD N 1/+/ m M AXD **1** 2 n n AXD 0 C + + B AXD + + AXD Ga 0+ 4 AXD V 1 5 3 + AXD 2 AXD AXD U AXD + AXD Ŵ 0 7 7 11 N AXD F AXD Y + Ø AXD

19

Letter Groups

When creating minuscules, keep your eye out for similar shapes and structures while forming the letters. Paying attention to these similar shapes—and aiming to keep them similar in appearance—will create flow and evenness throughout your writing.

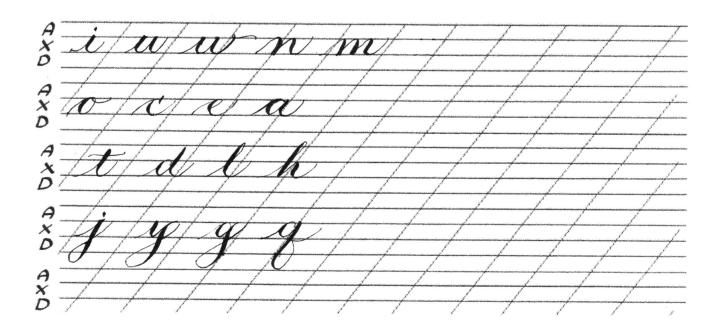

Here's an idea! Practice with a sharp pencil. Pencils still allow you to create thick and thin strokes (although not as dramatic as the pen), without any splattering hazards! The smoothness and ease of using pencil is very satisfying. Just remember to push on the downstroke, and pull on the upstroke!

Majuscules

Practice these strokes before working on majuscules. You'll find that mastery of these lines will help make your capital letters flow more beautifully!

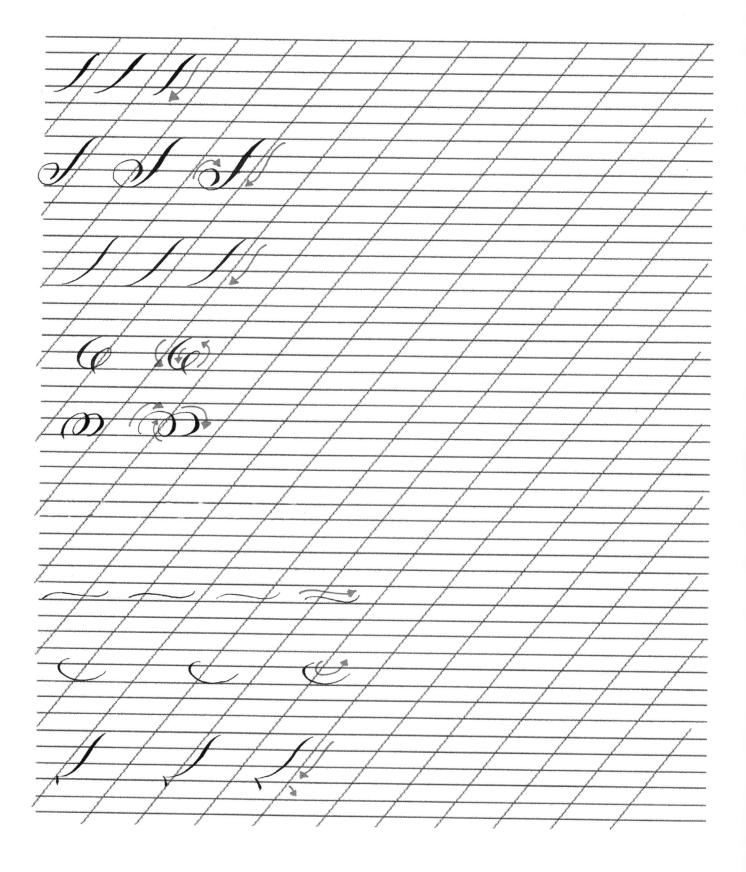

As you practice writing majuscules, aim for smoothness with your pen, letting the strokes flow into one another. Follow the arrows in my examples; remember to push on the downstrokes and pull on the upstrokes. Never write in all capitals when using calligraphy styles.

AXD XD XD AXD AXD

Tidying Your Letters

Not happy with how a part of your letter turned out? It's not too late! While the ink is still wet, use the tip of the pen nib (make sure it isn't loaded with ink) to carefully drag the wet ink into the desired shape. Use this trick to create squared-off ends in your strokes, adjust the thickness of strokes, and smooth any bumpy lines or uneven patches. Perfecto!

AXO A XD + AXD AXD AXD AXD AXD AXD AXD AXD 7 A X D ţ AXD + It AXD +/ AXD AXD T AXD + > AXD

· · · ·

24

Joining Letters & Forming Words

Aim to join letters at the exit strokes, as they would naturally flow together. Try to avoid awkward connections or crossing lines. As you practice, you'll find that you can sometimes write several letters—or even a whole word—without lifting the pen!

AXD UMI M AXC XD AX C AXD iota AXD AXD AXD mat AXD

Taking It Up a Notch

YES—IT'S TIME TO TAKE YOUR LETTERING TO THE NEXT LEVEL! Now that you've practiced the basic strokes and put them together, first in shapes and then words, let's expand your repertoire with an upright script. Then we'll start embellishing!

This upright script is loose and free—have fun with it! Notice that the letter shapes and strokes are the same as the slanted script you have already learned, but they are drawn upright. As with slanted script, it's still very important to maintain even spacing between and inside the letters. Each letter should take up roughly the same amount of space.

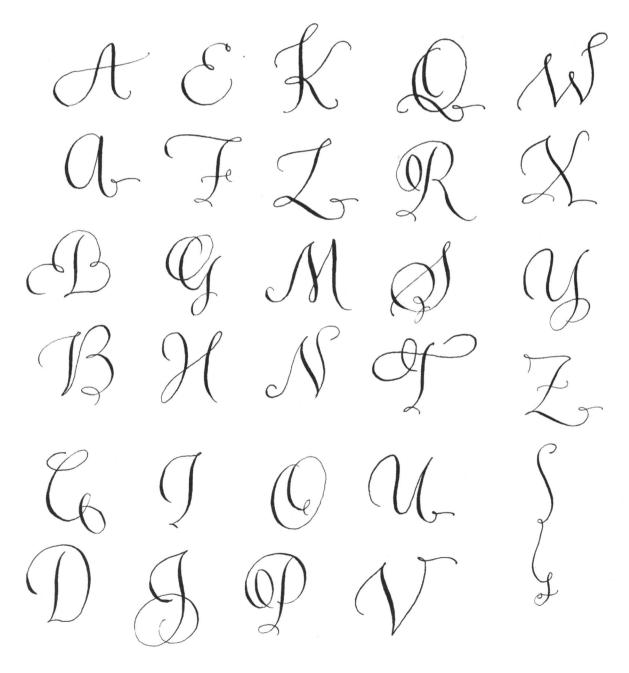

ab c de fg hij K l m n o p q v s t NNWN C Y and S (c)29

GLOSE MP/ 6 PULL Dy5HI 2. PULL P4541 CLOSE и Р !! 1. ? 2. 8. 3

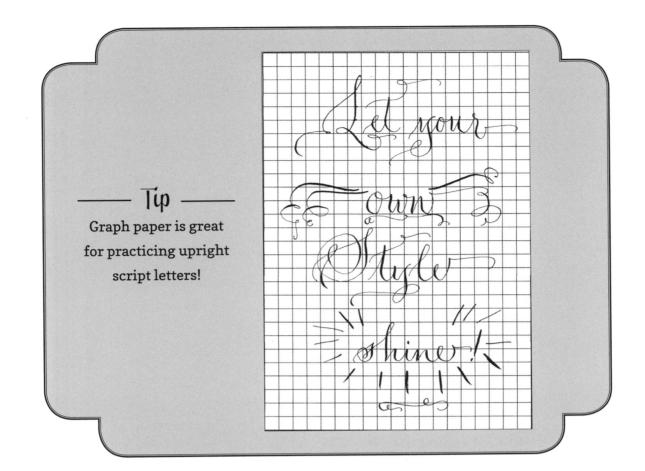

How to Let Your Lettening Shine

With practice and over time your own unique calligraphy style will emerge. You will naturally discover certain letters, shapes, and strokes that are most comfortable for you. Perhaps you will find that you are drawn to ultra-flourished capitals and lots of swashes. Or maybe you will be most comfortable with a pared-down, loose, casual style. Whatever style you feel emerging, go with it! Here are some suggestions to help you get started.

- **Study** and master the basics. Practice the strokes that form basic letter shapes. Then practice some more! Don't skip this step; the only way to develop your own style is to master the basics first.
- Familiarize yourself with the traditional pointed-pen lettering hands. Experiment with creating the traditional letters of Copperplate/English Roundhand and Spencerian.
- **Purchase** a broad-edged pen nib, and try creating Italian letterforms. Many calligraphy teachers recommend learning Italian hand as a base for calligraphy studies.
- Join a local calligraphy club, or check out the calligraphy section at your local library or bookstore.

Embellishing

AND NOW...LET'S FLOURISH! Follow the tips below to keep your flourishing and swashing natural looking, free flowing, and smooth!

>

Tips

- Give flourishes room to breathe.
- Return flourishes to where they began, trying to maintain a "sense" of a circular or oval shape in the flourish.
- Never cross thick flourish lines.
- Thin flourish lines can be crossed, but do so sparingly!
- Aim for delicate lines and smooth curls.
- Try to keep your movements smooth and natural, with lots of arm action-don't keep your hand planted on the table!
- Flourishes tend to flow either horizontally (from a letter or word) or vertically.
- Avoid abrupt endings, sharp corners, and hard angles.
- Create flourishes that extend from the beginning or end of words.
- Make sure your words are always readable. Avoid overly flourishing if it compromises readability.

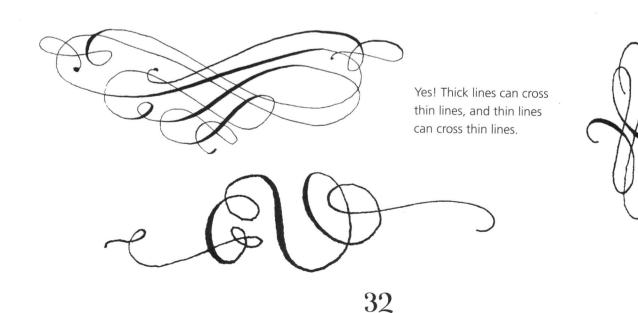

▲ These letters naturally lend themselves to pretty flourishing.

▲ No! Don't cross thick, heavy lines.

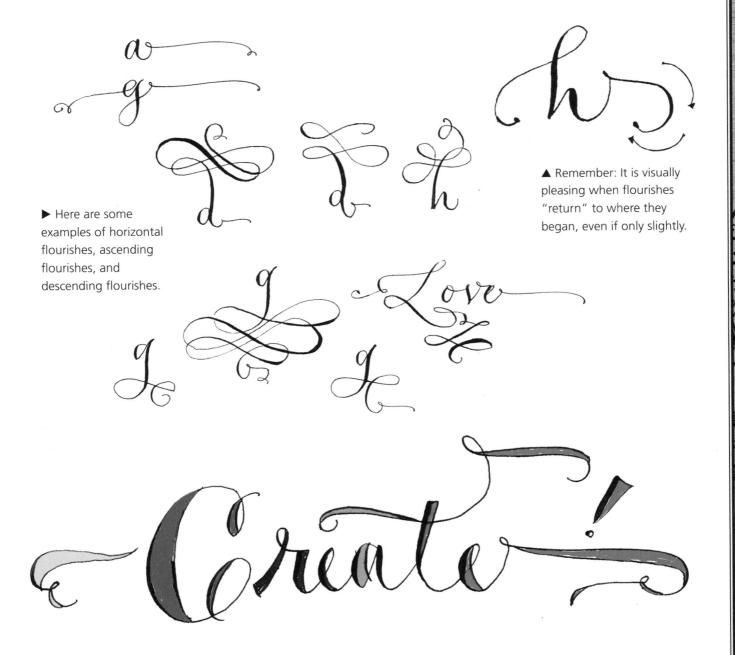

Flourished Capitals

Give capital letters lots of space, and avoid squeezing the next letter of the word into the flourishes. Look for balance and composition, and remember to avoid crossing thick lines.

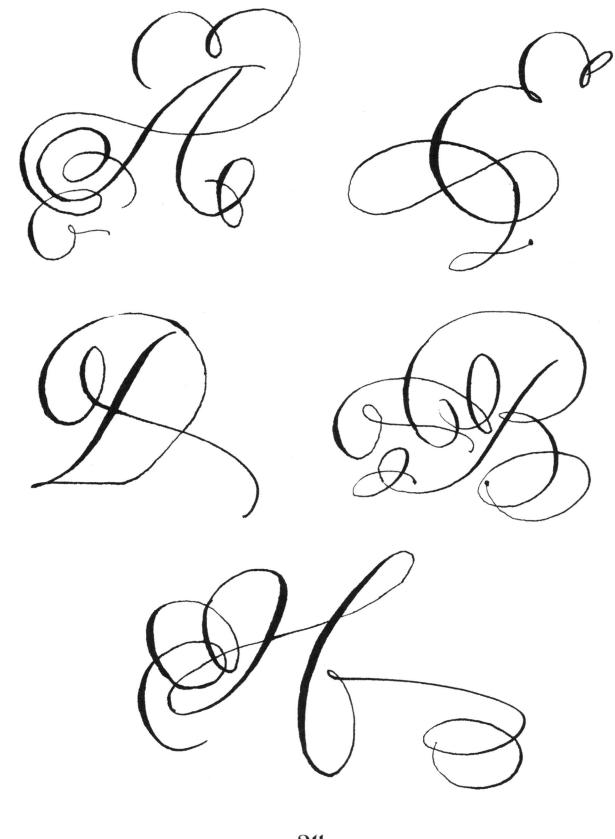

One Letter, Many Flourishes!

Here are a few ways to flourish a capital "S." Can you think of more?

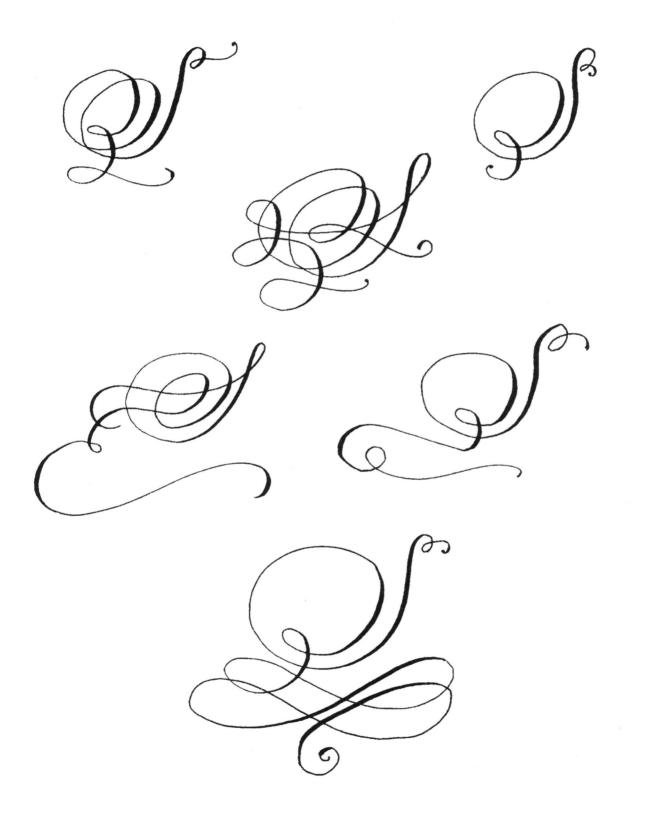

Creating Swashes

To create lovely swashes, start at the top and work slowly downward. Very gently pull the pen along the straighter parts of the flourishes, and apply a bit of pressure to create thick lines. The flourishes below were created with jelly pens—these pens are very fun to use and can create unique designs!

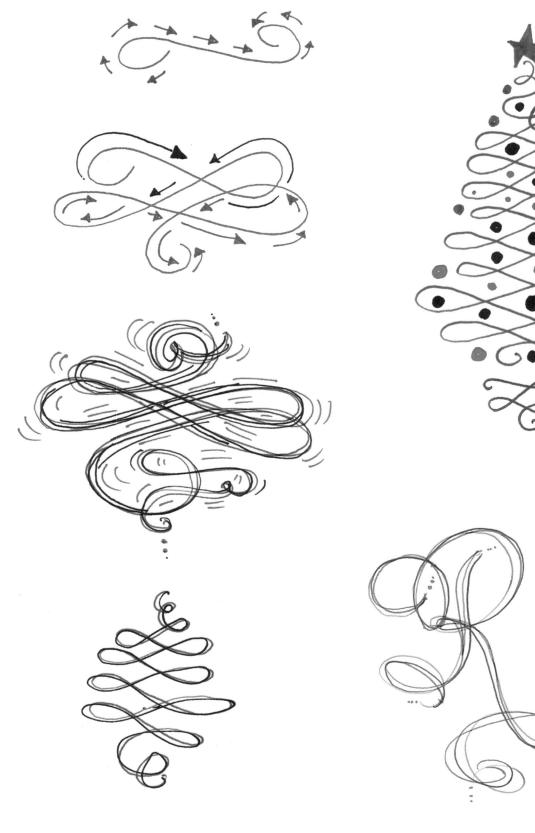

 $\left[\right]$

OYGBIL

Numbers & Borders

DON'T FORGET NUMBERS AND PUNCTUATION MARKS! These characters benefit from pretty flourishes and strokes too.

01234567891? 0123456789~ 01234567891P 0123456789!? 1234567

----- Τφ -----Keep your embellishments small, as these kinds of characters generally need to stay close to other letters and numbers. You can craft pretty borders, boxes, and other small embellishments to bring even more dimension to your lettering. Here are just a few examples to inspire you.

Illustrated Lettering

WITH GABRI JOY KIRKENDALL

HAND LETTERING IS THE ART OF CREATING BEAUTIFUL LETTERS. The beauty doesn't stop at the letters but reaches out visually, through which they have great subconscious power to speak to us.

Every time you hand letter, you communicate through your font choice, style, and illustrative touches. Many see hand lettering as a new, trendy sort of art; in some ways this new manifestation holds its own unique place. However, hand letterers follow in the footsteps of age-old traditions, in which you can harken back to the days of monks lovingly hand lettering and illuminating manuscripts—centuries before the invention of printing!

It was this ageless mystery of words that first drew me to hand lettering. I loved words from an early age, and I always had a book with me—up a tree, in the grocery store, in the car on the way to school. I loved books and the amazing worlds that opened to me in their pages. I even kept a quote journal where I recorded favorite bits. I always admired art that incorporated quotes or messages. Perhaps this is where my love of hand lettering—and understanding of the potential of this ancient and powerful medium—began.

The art of hand lettering has allowed me to take beautiful, inspiring words that I love and make them beautiful in a whole new way. I hope this is something you will experience as well!

45

Getting Started

WHEN IT COMES TO BEAUTIFUL, EXPRESSIVE LETTERING, the possibilities are endless. From pencils and markers to pens and paints, you can use just about any mark-making tool to craft pretty letters and words. On the following pages, I'll introduce you to some of my favorite lettering tools, techniques, and inspirations, including some of the fun materials you'll need to complete the step-by-step projects in this section!

THE BASICS FOR HAND LETTERING:

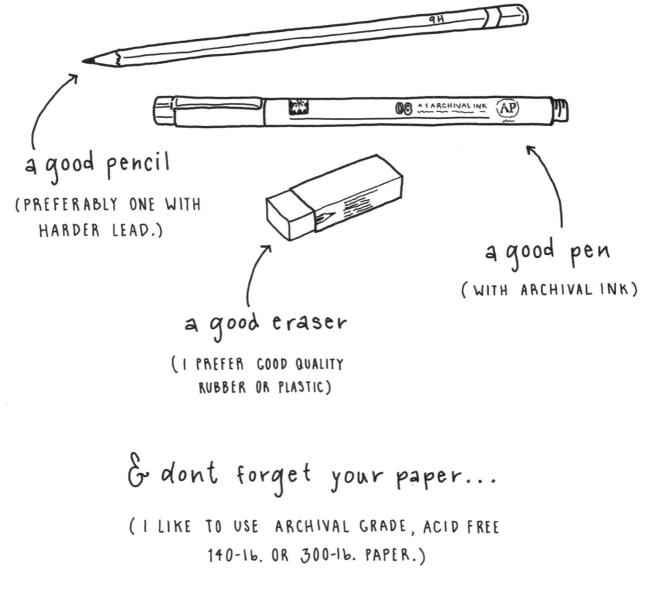

A GUIDE IO pencil hardness

2H

3H

5 H

6 H

PENCIL LEAD COMES IN A RANGE OF HARDNESSES

9B = VERY SOFT 9H = VERY HARD

FOR HAND LETTERING I LIKE TO USE HARDER LEADS BECAUSE THEY DON'T SMUDGE AS EASILY AND THEY ARE EASY TO ERASE WITHOUT A TRACE.

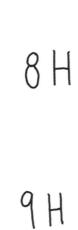

BEYOND THE BASICS

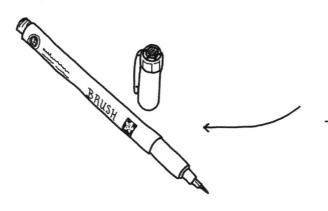

BRUSH PEN

-My favorite for expressive flourishes and **bold** script.

ERASER SHIELD

-In hand lettering you end up working with a lot of fine lines - so you need an eraser shield so you only have to erase what you need to.

WATERCOLOR BRUSH PENS

- These pens are <u>so much fun</u>! They allow you to create the look of watercolor without the mess Of brushes & paint, and with more control - a beautiful way to add color to your work.

WHAT IS A SERIF?

"Any of the short lines stemming from and at an angle to the upper and lower ends of the strokes of a letter."

- MERRIAM-WEBSTER

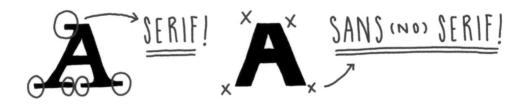

<u>SERIF</u> FONTS ARE ... <u>SANS SERIF</u> FONTS ARE ... - authoritative - universal - traditional - modern - respectable - solid - classic - fashionable - elegant - clean

(STILL WONDERING? - just follow your mood.)

Internet NEED A FUN WAY TO PRACTICE? TRY CREATING AN alphobet BCDEF JH, IJK L NOPQR S X,

MATA

· MIX · FONTS · LIKE · A · PRO ·

Knowing how to skillfully and artistically mix fonts is intrinsic to becoming a great handlettering artist. Fonts can generally be divided into different groups depending on their aesthetic construction. The basic groups are: *serif, sans serif, script,* and *decorative.* There are no hard-and-fast rules on how to combine different fonts, and every artist has their own favorite combinations. Here are some examples of how fonts can be mixed.

BOLD & DEFINITE -mixed with a fun cursive -SIENDER AND VILLOVI paired \cdot with \cdot something \cdot bolder a pit of formal fun WITH JUST PLAIM FUN C. Remember 7 OPPOSITES + CAN + GO + TO GETHER 7

Additional Tools & Mediums

Watercolors

Watercolor paint is a fluid medium with airy and atmospheric qualities. Watercolors come in tubes, pans, pots, or pencils. Tube paint is easiest to work with, as it is readily mixable. Lighten watercolor washes by adding water to the paper or the paint—or both! Use watercolor paper, which is designed to support this wet medium, when working with watercolors.

Acrylics

Acrylic paint is water-based, which means it can be diluted with plain water. For the free-brush lettering project on pages 62-63, I use black acrylic paint. You might consider purchasing one or two colors to start with; you can always expand your collection if you enjoy working with the medium!

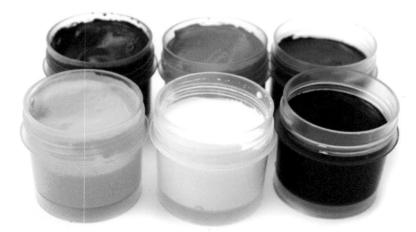

Gouache

Gouache is a more pigmented version of watercolor paint. It has an opaque, chalky quality with a matte sheen and soft, flat appearance. Gouache comes in tubs or lidded pots. When you work with gouache, be sure to use heavier paper, such as watercolor paper or illustration board.

Brushes

You don't need to purchase expensive brushes for your lettering projects. Just collect several sizes, shapes, and types. Care for your brushes by cleaning them after each use with cool running water and mild soap, pressing the bristles into the palm of your hand to loosen pigment. Acrylic paint dries very quickly, so be sure to wash your brushes promptly when working with the medium, as it is difficult to remove once dry.

Here is a quick guide to what types of brushes to use with different paints:

- Acrylic Use soft synthetic-hair brushes, which can withstand the caustic nature of acrylic paint.
- Watercolor & Gouache Soft natural-hair brushes (such as sable) work well with these mediums because they hold a good amount of moisture; however, you can also use soft synthetic-hair brushes.

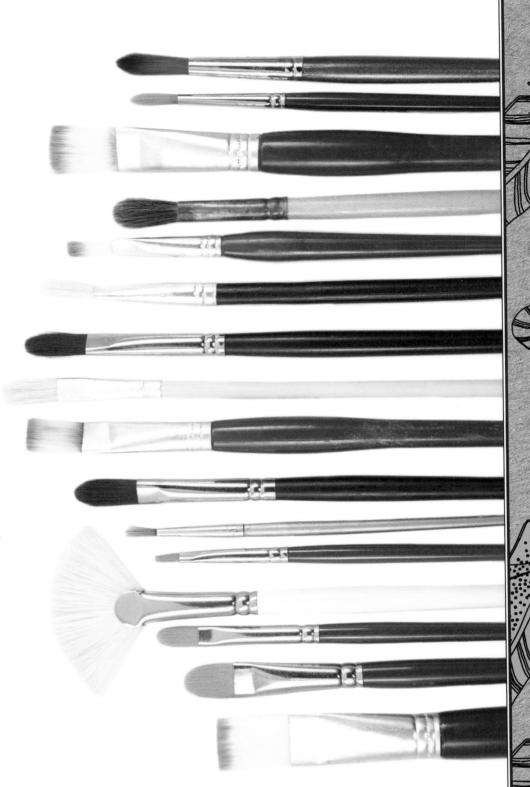

Pens & Markers

There are lots of fun pens and markers available today for writing, drawing, and doodling on just about anything, from ceramic to fabric to glass! For some of the projects in this section, you'll need a glass paint marker and a porcelain pen. You can find these items at your local art & craft store or from various online retailers.

Lettening Exercise

Create the Calligraphy "Look"

BEAUTIFUL CURSIVE SCRIPT COMPLEMENTS any hand-lettered piece. If you're still perfecting the calligraphy techniques from the previous section, this simplified technique is a good alternative to achieve a similar effect. It does not replace or devalue calligraphic skill, but it can help create the look you desire as you develop your calligraphy skills.

We were

WALT

WHITMAN

► STEP TWO Sketch thicker lines that mimic the change in thickness seen in traditional calligraphy.

we were

On O A. WALT WHITMAN-

we were together. rgettherest. -WALT WHITMAN-

ve were together. ĕ :©: 1. reres -WALT WHITMAN-

STEP FOUR Erase the pencil marks, and add any desired illustrative touches.

Lettering Exercise

Blocking

BLOCKING IS ALWAYS MY FIRST STEP when I start a project. It allows you to visually plan the lettering before you begin inking.

STEP ONE Select a quote, and divide it into blocks of individual words or groups of words. Sketch a block or illustrative element for each word or group. WE

-have-to-choose-

and Keep choosing it.

- HENRI J.M. NOWEN-

STEP TWO Choose your fonts, and sketch each word or word group in its corresponding block space.

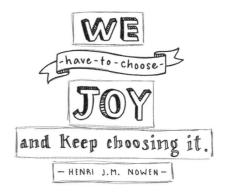

STEP THREE You are now ready to ink! Carefully trace over your sketches with your choice of pen.

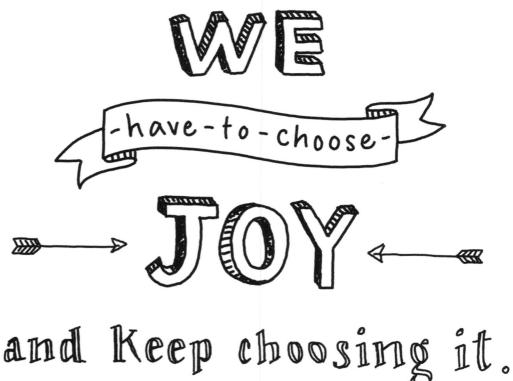

NOWEN-

You - HENRI J.M.

STEP FOUR Once you are finished inking, erase your pencil marks. You can also add embellishments or final touches, like the arrows I added to fill in the silhouette.

Experiment with different combinations of geometric shapes. Here is a more complicated example. Sketch out the blocks first and then the words. Once the words are sketched in, you can erase the blocks. For a different look, I used a colored background, and a white opaque ink pen to letter the words.

Lettening Exercise

Lettening in Shapes

ONE OF MY FAVORITE HAND-LETTERING SKILLS is to letter in shapes. This technique is not only fun but also visually pleasing and great for creating graphic work that is ready to print on cards, T-shirts, or tattoos.

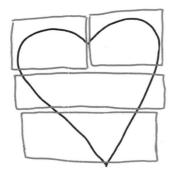

STEP ONE Pick a quote and shape. Sketch the shape, and then use the blocking technique to plan your word placement.

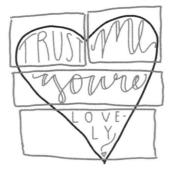

STEP TWO Sketch the words into their blocks, following the outline of the shape. Use embellishments to fill out the shape if necessary!

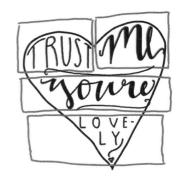

STEP THREE Trace the letters and shape with a pen.

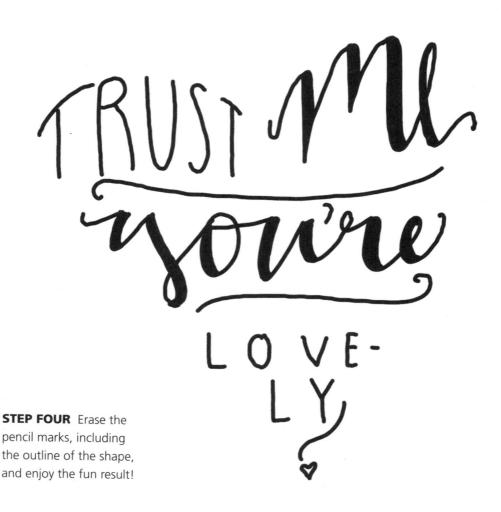

58

For this shaped text, I chose a quote that I love by Ernest Hemingway: "There is nothing noble in being superior to your fellow man; true nobility is being superior to your former self."

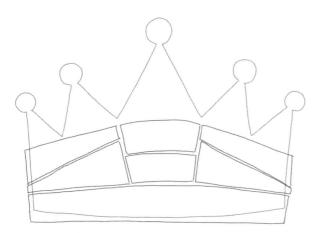

I chose a crown shape to play off a symbol of nobility and blocked out the words in symmetrical geometric shapes.

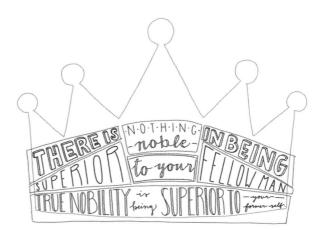

I sketched in the words, following the symmetry of the blocking by also mirroring my choice of fonts.

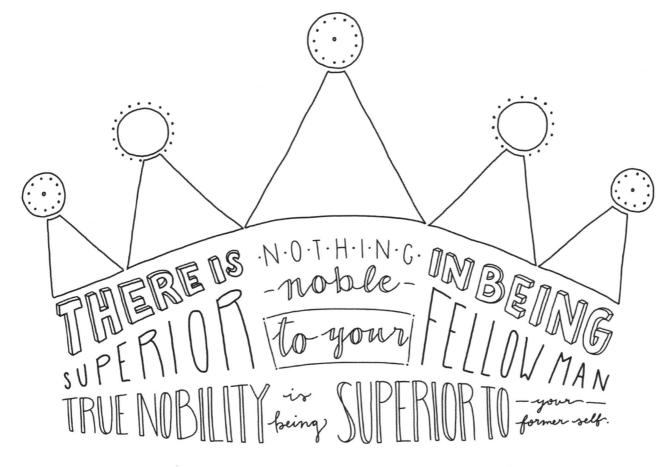

I completed the design with illustrative elements, including a simple geometric theme to finish the spikes on the crown.

Step-by-Step Project

Free-Brush Lettering on Canvas

CREATE A NEW PIECE OF ARTWORK for your home or as a gift for someone special. This fun step-by-step project requires just a few supplies and can be completed in a couple of hours!

Materials

Blank canvas Black and white acrylic paint Medium, flat acrylic paintbrush

r my part I ow nothing h any tainty, but sight of the s makes me m. **nt Van**

STEP ONE Assemble a canvas, white and black acrylic paint, and a medium, flat acrylic paintbrush. Select the text you would like to letter on your canvas. My choice is a quote from Vincent van Gogh: "For my part I know nothing with any certainty, but the sight of the stars makes me dream."

For my part I know nothing with any certainty, but the sight of the stars makes me Iream. **incent Van** ogh

ofth mesmed fincent Un Nor

STEP TWO Prep the canvas with a layer of white paint to provide a better surface for lettering. I chose to "rough paint" my canvas, leaving uneven texture to give it a more organic look. Let the paint dry before sketching the letters in pencil. Choose your font(s) carefully. You want fonts that are easy to letter freehand. Cursive or brushed letters work well.

Draw ruler lines on the side of the canvas to help you fill the canvas evenly. Simply erase the marks when you're done!

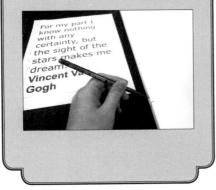

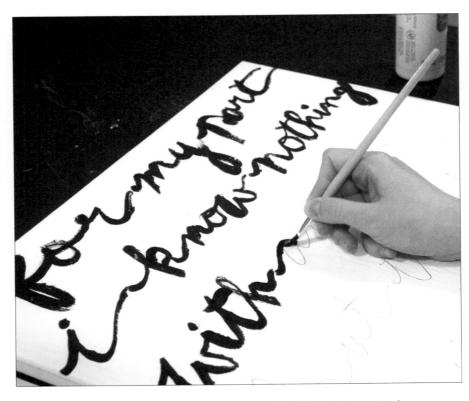

for my port i know nothing with any certainty hat the sight of the stars makes medicon rincent Un 1

▲ **STEP THREE** Paint! Use large, expressive brush strokes, keeping your wrist loose. Don't worry if you make a mistake. Mistakes add character! Hand lettering isn't about perfection; it's about expression. You can always use a bit of white paint to correct mistakes later.

◄ STEP FOUR Allow the paint to dry completely before correcting any mistakes with white paint. Then hang your new piece of artwork.

Step-by-Step Project

Hand Lettering on Glass

FOR THIS PROJECT YOU WILL NEED a piece of glass (not mirrored) and a glass paint pen of your choice. I used an antique window I found at a yard sale.

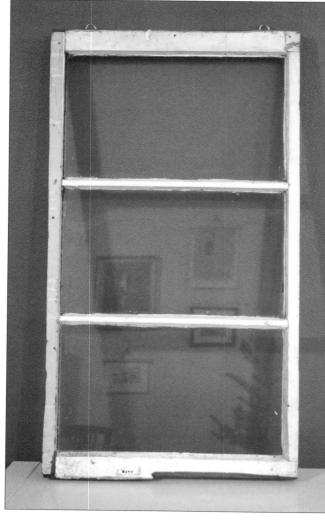

STEP ONE Clean the glass first. Use soap and water or a glass cleaner. Wipe the glass again with a damp cloth or paper towel to make sure there is no residue left on the surface.

STEP TWO Select a quote and your favorite fonts. Then type the quote in the desired fonts and size them appropriately before printing.

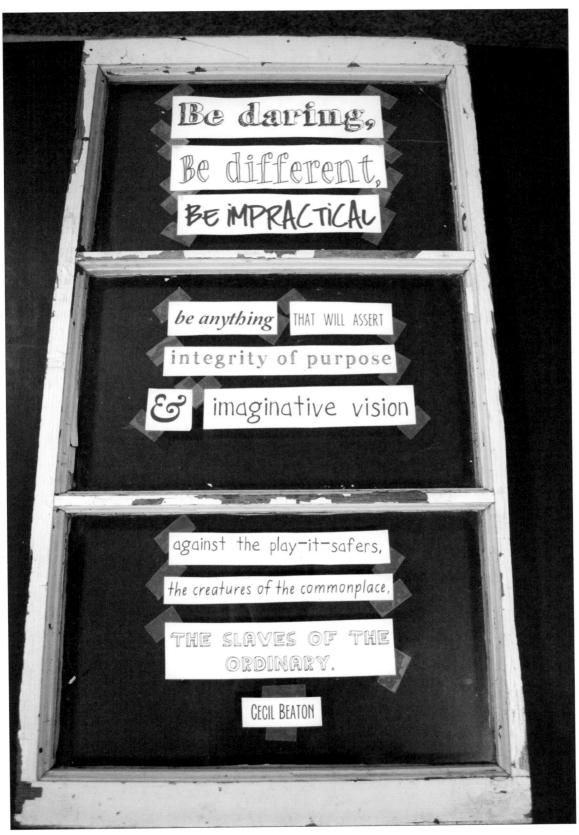

STEP THREE Cut out the words and tape them in the correct order and position on the underside of the glass. Experiment and move things around until you are happy with the composition.

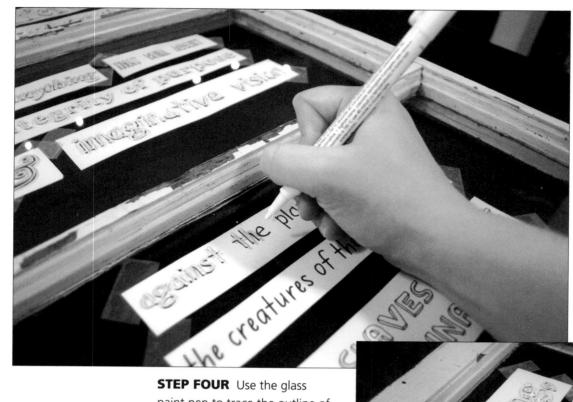

STEP FOUR Use the glass paint pen to trace the outline of the letters on top of the glass. If you make a mistake, simply use a wet cloth to wipe away the paint completely before it dries. Then try again.

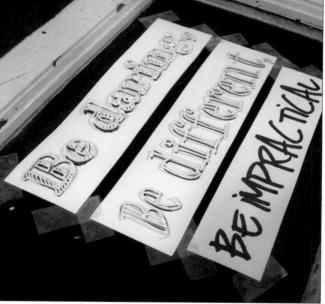

STEP FIVE Add embellishments or illustrations. Remove the paper from the back of the glass.

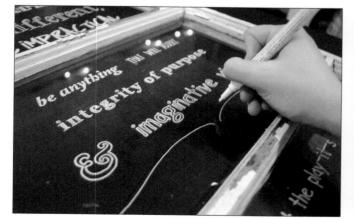

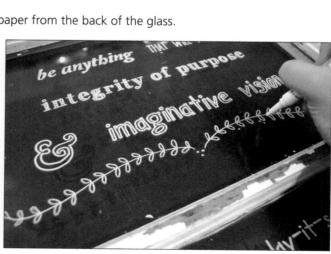

STEP SIX Hang and enjoy your unique piece of art!

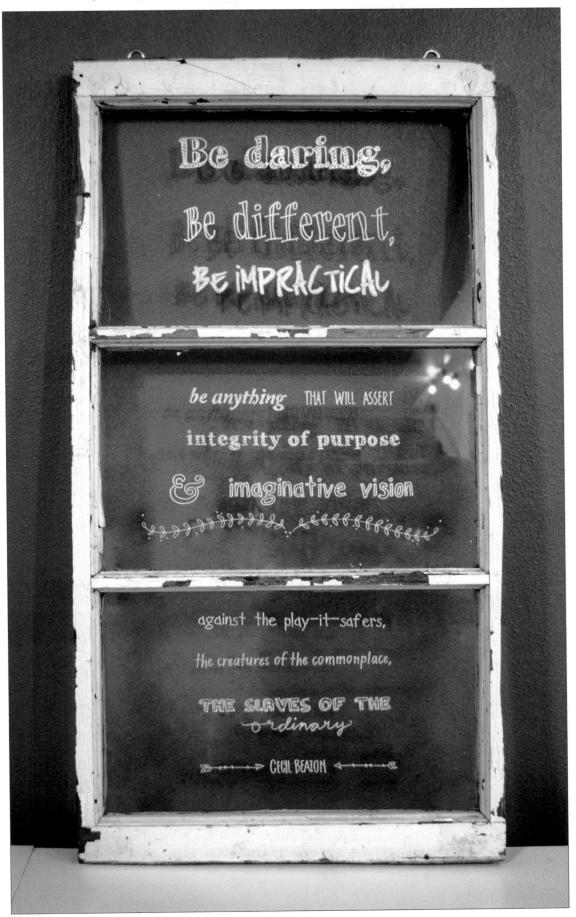

Lettering Exercise

Converting Hand Lettering to a Digital Format

Now THAT YOU'RE GETTING THE HANG OF HAND LETTERING and loving your results, it's time to open yourself up to a whole new realm of opportunity. All you need is a camera, a computer, and Adobe® Photoshop® or similar photo-editing software. Once you learn to convert your work to a digital format, you can create any number of projects, from printed fabric to temporary tattoos and so much more!

what you need to get started DIGITAL CAMERA

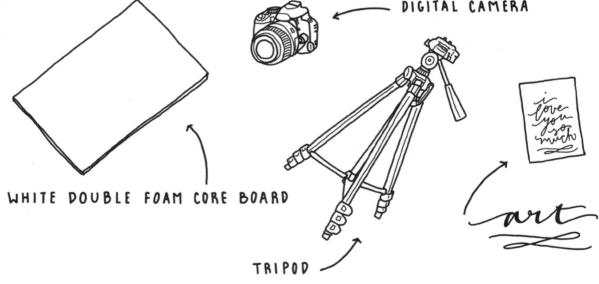

STEP ONE The first step is to photograph your work. You need a few basic supplies: white double foam core board, a digital camera (preferably a DSLR), a tripod (optional if you have a steady hand), and a piece of your art!

-how to set up your photoshoot LIGHT SOURCE (WINDOW OR LAMP)

STEP TWO Use the illustration above as a guide to set up your photo shoot. Choosing a light source is the most important thing. If it's available, natural light, such as near an open window, is always best. Position the light source to the side so that it can reflect off your foam board and properly light up your subject. If you can't use natural light don't worry! You can either buy a full-spectrum light bulb or play with the white balance on your camera.

	Photoshop File Edit Image Layer Type Select Filter	3D View Window Help	▲ M1 ① + 중 40 ④ Thu 4:57 PM 및 ==			
il you have good thoughts THEY WILL SHINE out of gour face hock - Covely: 	Adobe Photoshop CC					
Image: State Stat		100x - Cf Ø	Essemais +			
	- Line <	if you have good thoughts THEY WILL SHINE out of your face the SUNBEAMS				

STEP THREE Once you have snapped a couple of good photos and loaded them onto your computer, you are ready to start editing. First select your favorite file and open it in Photoshop or your photo-editing software of choice.

😫 Photoshop File Edit Image	Layer Type Select Filter 31	2 View Window Help	🜲 🕅 1 💿 🕂 🤶 🌒 💽 Thu 4:58 PM Q 🧮
000	New	Layer Track upper autoshop CC	
* *	Copy CSS Duplicate Layer Delete Rename Layer Layer Style Smart Filter	Layer from Background Group Group from Layers Layer Via Copy Still	
¥.	New Fill Layer New Adjustment Layer Layer Content Options		Layers Channels Paths 18
	Layer Mask Vector Mask Create Clipping Mask	if you have	Dave B C T I S I
4. 2.	Smart Objects Video Layers Rasterize	if you have good thoughts THEY WILL SHINE	keckpround
8.	New Layer Based Slice	THEY WILL SHUNE	
0.	Group Layers 36 G Ungroup Layers 12 96 G Hide Layers	out of your face	
Ø. 7 T.	Arrange Combine Shapes	like SUNBEAMS	
. .	Align Layers to Selection > Distribute >	AND got will Always look. lovely:	
·	Lock All Layers in Group	took lovely.	
	Link Layers Select Linked Layers	- Rended Dock	
	Merge Layers ೫ E Merge Visible 쇼울 E Flatten Image		
	Matting ►		

STEP FOUR Next create a new layer. Go to the Photoshop menu and click on "Layer," "New," and then "Layer."

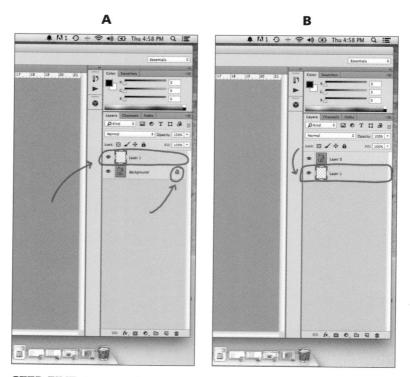

STEP FIVE Move to the layers palette on the right, and click on the small lock symbol to the right of the original image layer to unlock it (A). Then click on the new layer and drag it down below the original image layer (B).

70

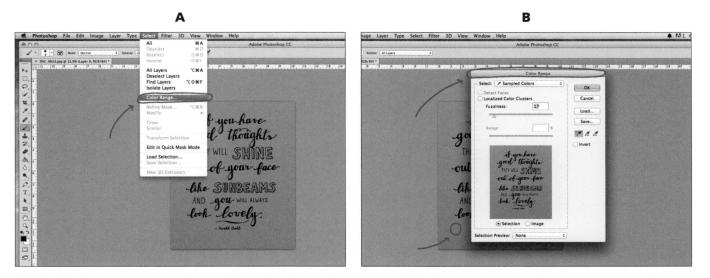

STEP SIX On the top menu, click on "Select" and then "Color Range" (A). This opens the "Color Range" window (B). Use the eyedropper tool to click on the background of the picture.

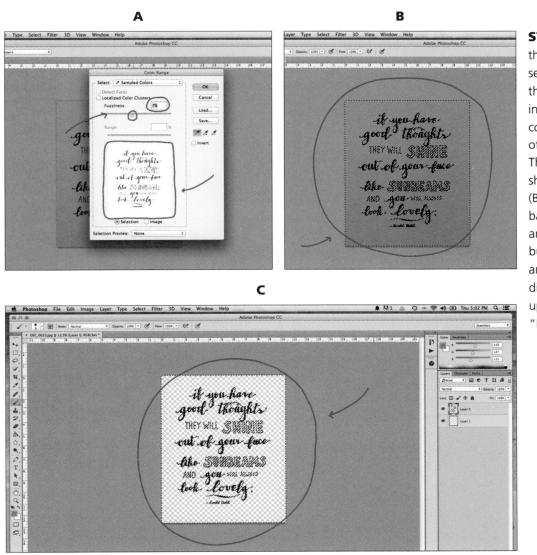

STEP SEVEN Once the background is selected, you can use the fuzziness slider to increase or decrease the contrast and the number of pixels selected (A). This determines how sharp your letters will be (B) once you delete the background. When you are satisfied hit the delete button on your keyboard, and the background will disappear. Then go back up to "Select" and click "Deselect."

71

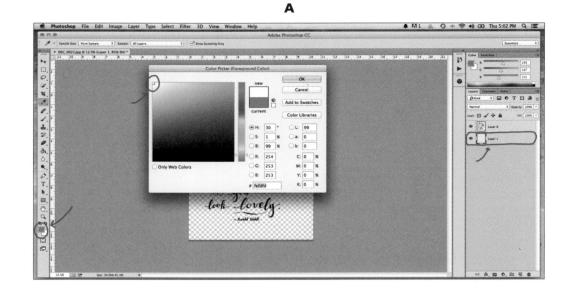

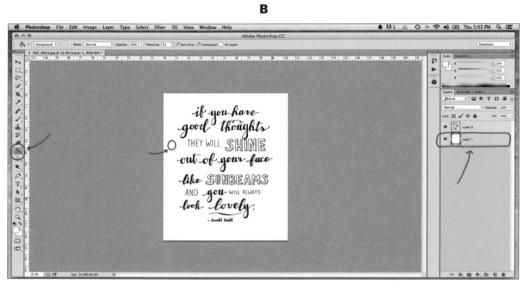

STEP EIGHT Now go down to the color selector, and click on the top box. The color selector will open and you can choose a background color (A). Then click on the second layer (Layer 1). Using the paint bucket tool, click on any part of the background to insert the new background color (B).

-if you have good thoughts THEY WILL SHIME out of your face like SUNBEAMS AND you will ALWAYS look lovely:

STEP NINE If you want to insert or drop your lettering over a different background, just click on the small eye icon next to Layer 1 to make the white background invisible. Then you are ready to save your work.

72

How to Place Art on a New Background

To place your digitized artwork on another background, open the background image (in this case, a pretty floral design) in Photoshop. Then drag and drop your lettering onto the open file. This automatically creates a new layer. You can customize the size and placement before fully placing it on the page by double clicking. Then save your work!

if you have good thoughts out of your face like SUNBEAMS look lovely if you have good thoughts CETHEY WILL out of your like SUNBEA AND you will Always look lovely. - Roald Dahl

73

Step-by-Step Project

DIY Temporary Tattoos

Now THAT YOU KNOW HOW TO TURN your beautiful hand lettering into digital formats, try making these fun temporary tattoos. All you need is your hand-lettered art, the photo-editing software of your choice, and tattoo paper. Be sure to use the type of tattoo paper appropriate for your printer. For example, the tattoo paper I used in this project is designed for inkjet printers. Each type of tattoo paper comes with its own instructions for application. These fun tattoos make great party favors and are perfect for everyday use!

STEP ONE Use photo-editing software to convert your lettering to a digital format (see pages 68-73). Then get your printer ready to print onto the tattoo paper. Read the paper instructions carefully; you may need to recalibrate your printer for paper with a different texture and weight. Check to make sure it will print on the right side, too!

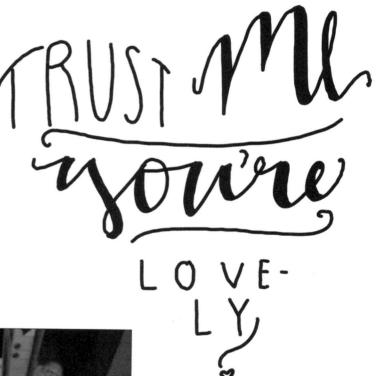

STEP TWO When your printer is set, print the digital files. Allow the ink to dry fully.

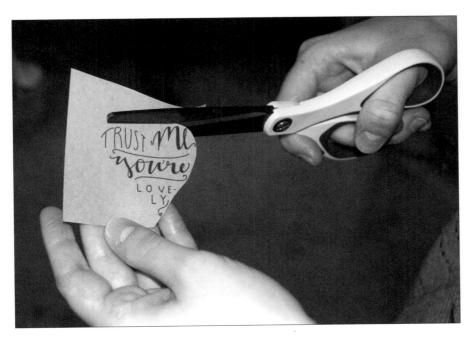

Use a washcloth and warm water to clean the skin before applying the tattoo; this will help it last longer.

STEP THREE To make the tattoos easier to apply, cut around the letters.

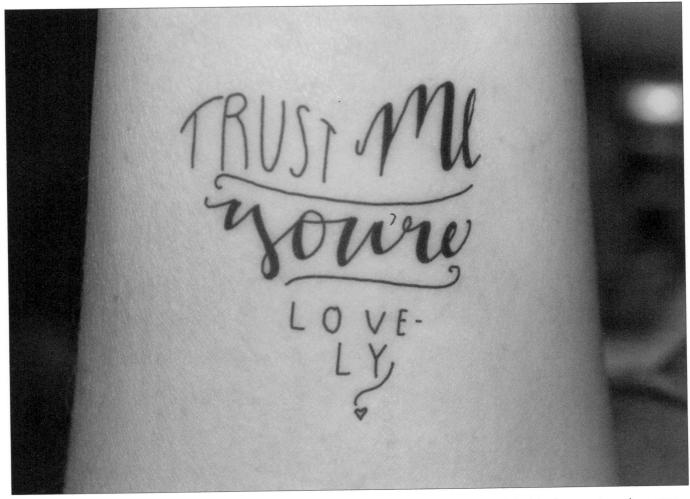

STEP FOUR Following the instructions that came with your tattoo paper, apply the tattoo ink-side down onto a clean area of skin. Press on the tattoo, starting at one edge and gently rolling the design onto the skin to avoid creases.

Lettening Exercise

Ribbon Lettering

RIBBON LETTERING IS A FUN WAY to add personality and a unique look to your lettering. Practice this basic tutorial to get the hang of it, and then take it to the next level with the example on page 77.

STEP ONE Trace or sketch the word in cursive, adding any desired twists and flourishes.

STEP TWO Think about how a ribbon would twist and overlap as it forms the letters. Trace this second set of lines.

STEP THREE To create the illusion of ribbon, carefully erase lines where one part overlaps another.

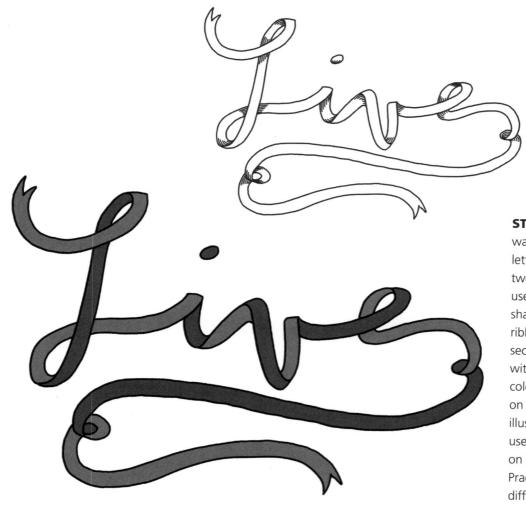

STEP FOUR There are several ways to add depth to ribbon lettering. I have demonstrated two ways here. The first is to use simple line shading to show shadows where one part of the ribbon overlaps another. The second is to color the ribbon with two shades of the same color, using the darker shade on the underside to create the illusion of depth. You can also use two different colors, one on each side of the ribbon. Practice several ways and with different colors!

Once you've mastered basic ribbon-lettering techniques, you can use them to create more complex art. Using the same basic steps on page 76, practice this more advanced ribbon-lettering example.

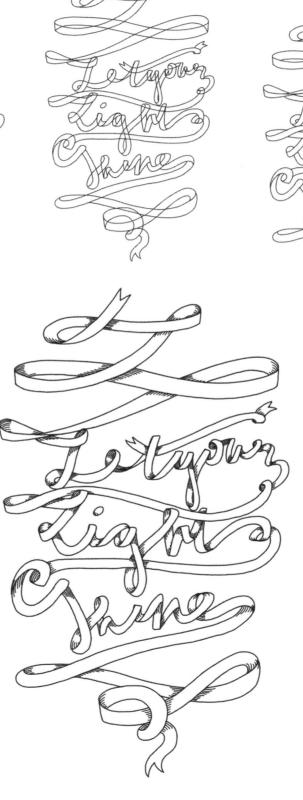

77

Lettening Exercise

Negative-Space Lettering

BASIC HAND LETTERING IS TYPICALLY PRACTICED with black or colored pens or pencils on white paper. To create a striking piece, try using *negative space*. Negative space is the area around an object or word. With this technique, make white letters against a dark background. The effect creates powerful works of art that stand out with shapes and geometric profiles.

► STEP TWO Sketch the outlines of the letters. Try to use simple fonts with bold profiles. Consider how the letters will stand out against a dark background, and sketch the outlines slightly larger than normal. Some of the size will be lost as you fill in the background. THE best thing D to <u>Hold ONIO IN</u> LIFE IS coch other ANDREY HEPBURN-

► **STEP THREE** Fill in the background, carefully following the outlines of your letters. I like to first outline the silhouette and the words with a pen to help me stay in line. As you fill in the shape, watch how the words begin to stand out from the dark background.

STEP ONE Sketch a shape or silhouette. I used a silhouette of a couple hugging because it reflects the subject of my chosen quote perfectly.

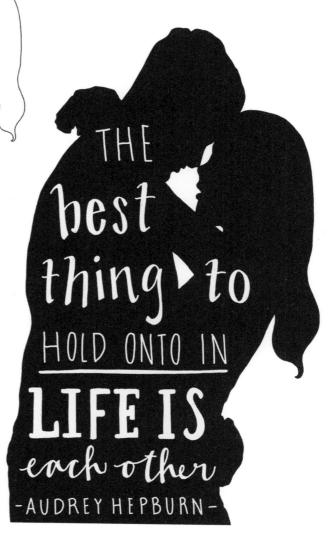

Playing with negative space can be addicting, thanks to the amazing black-and-white contrast that creates striking works of art. Here is another more advanced use of these techniques. As you get more confident, play around with more complicated fonts and illustrative elements. This technique is very effective in creating brand logos or custom stamps!

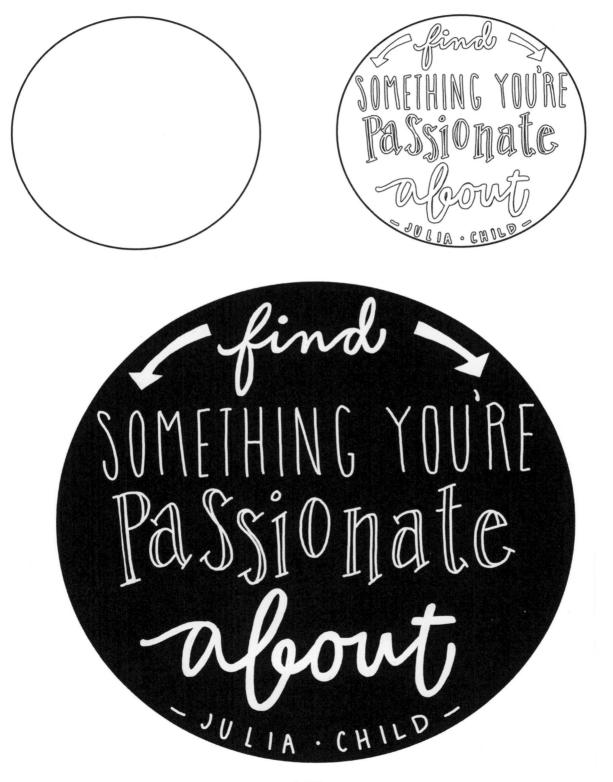

79

Lettening Exercise

Gouache & Watercolor Lettering

GOUACHE IS WATERCOLOR PAINT with varying degrees of opaqueness, thus allowing you to paint over initial layers of watercolor. I love using this medium because you can paint scenes, illustrations, or beautiful backgrounds to frame your lettering!

STEP ONE Begin by painting the background. To achieve an even wash of color, first paint the rectangle with water before adding several layers of dark blue watercolor paint (not gouache).

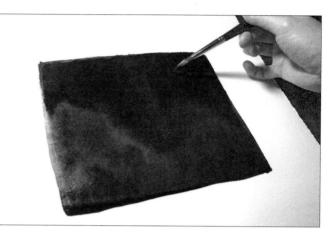

STEP TWO Add layers of paint, blending several different shades of blue to get the desired effect.

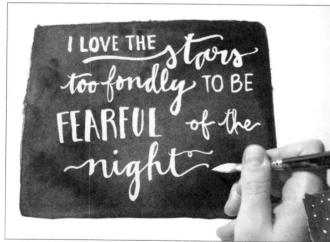

► **STEP FOUR** To complete the look, add a border of small white dots (using the same white gouache) to evoke the night sky. Once you are done painting, be sure to let the paint dry completely before moving, tilting, or hanging your new piece of art! ▲ STEP THREE Once the background is completely dry, begin painting with the gouache. I recommend using less water than you would normally with watercolor to keep the paint opaque and achieve integrity in your lines. If you don't feel confident lettering freehand, sketch the letters on a separate piece of paper first to practice. I chose a quote by the poet Sarah Williams: "I have loved the stars too fondly to be fearful of the night."

too fondly

82

Before I fell in love with hand lettering, my first love was watercolor painting. Watercolor paint is fluid and expressive—two things that lend themselves beautifully to hand-lettered art. For this exercise, select a favorite quote or phrase. I chose a quote close to my traveler's heart: "Not all who wander are lost," by J.R.R. Tolkien.

STEP ONE Lightly sketch the outline of the words. I find it best to use a pencil with fairly hard lead, such as a 6H or 8H. Softer lead might mix with the watercolor paint, clouding the paint and creating smudged edges. Don't forget to add any embellishments or illustrations.

STEP TWO Begin painting. I like to paint with a fairly wet brush, sometimes even adding water to the paper before painting to achieve a fluid tension that allows the paint to stay in the letter shape while also mixing and marbling for a pretty effect.

STEP THREE Continue working until all of the letters are painted. It's okay if your letters aren't perfect. The fluidity of watercolor produces organic results that add to the charm of the piece.

STEP FOUR You can leave your lettering as is for a simple look, or you can add illustrative details. I added an outline of pine trees, evoking scenes from my favorite places in the Pacific Northwest.

Lettering Exercise

Illuminating Letters

ONE OF THE OLDEST FORMS OF HAND LETTERING is the beautiful illuminated scriptures you can find in famous cathedrals and colleges across Europe. My favorite part is the individual illuminated letters, hand drawn and illustrated by the monks. To get started on your own illuminated art, pick your favorite letter and choose one "doodle" or design to add character.

STEP ONE Trace or sketch your letter of choice, and select a doodle or design to fill the letter. I chose a combination of small dots and illustrated vines. Once you are happy with your design, ink over your pencil lines.

STEP TWO Erase the pencil marks and admire the result! There are many fun applications for illumination, including custom initials or monograms, striking wall art, designs that can be transferred onto shirts or bags, and other endless possibilities.

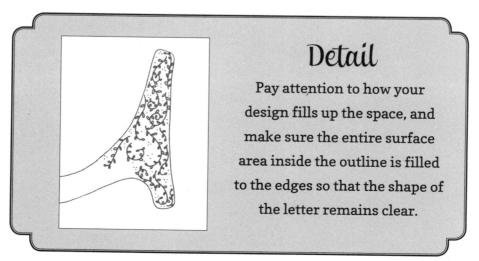

If you find yourself falling in love with illuminated letters, take it to the next level! Practice combining different illustrations within a single illumination. In this example, I illuminated a classic and elegant ampersand with beautiful flowers for a stunning effect.

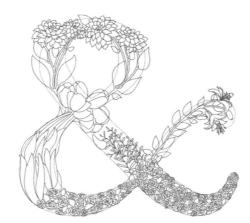

STEP ONE Trace or sketch the outline of your letter, and begin to sketch your illustrations. I worked from the ground up since that is how flowers grow. Erase and redraw as needed until you are satisfied.

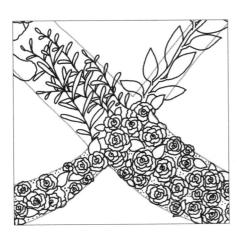

◄ STEP TWO Once the illustrations are complete and you are satisfied with the result, ink the outlines. I like to sketch the outlines of the illustrations first, saving inner details and shading for last. (see "Details").

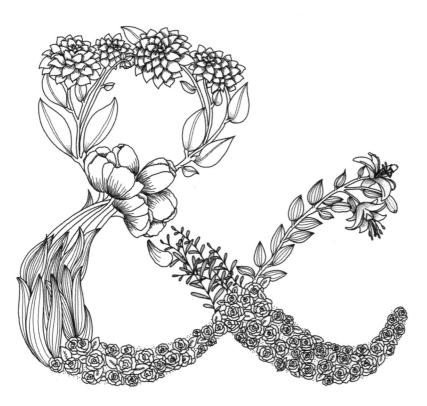

STEP THREE Now you can add small details to complete the design, such as veins on the leaves and shading to give the flowers depth. Fill in any spots that are blank to make sure the silhouette of the letter is full and true. Once you're happy, erase the pencil marks!

Lettering Exercise

Negative Illumination

ILLUMINATION IS A BEAUTIFUL TECHNIQUE. To put a twist on it, flip it to create a negative image!

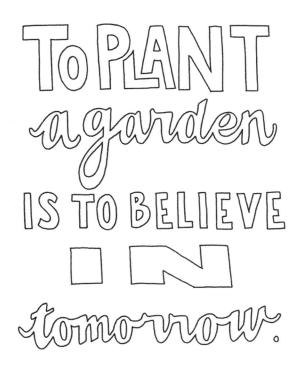

◄ STEP ONE Choose a quote, and sketch the outlines of the letters. When you are satisfied with the sketch, ink the outlines of the letters and erase the pencil marks.

► **STEP TWO** Sketch out the illustrations, this time around the letters and not inside them. Take your time. Once you're happy with the look, ink the illustrations and erase the pencil marks.

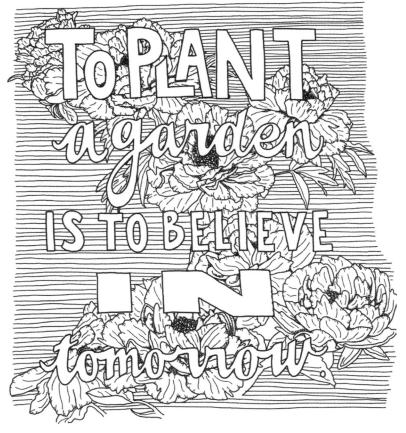

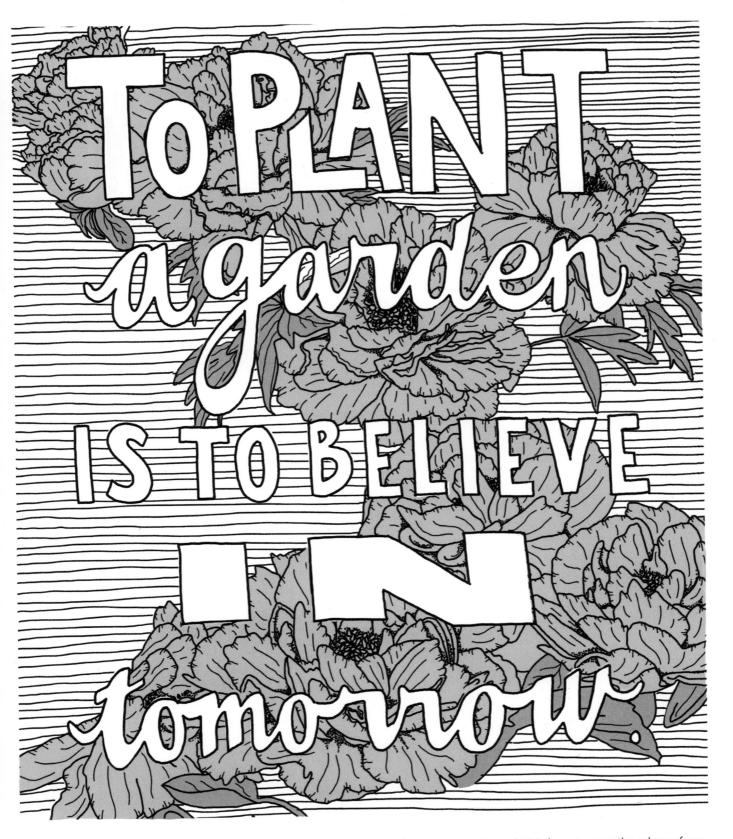

STEP THREE You can add color to your design digitally or with markers or watercolor paint! I chose to crop the edges of my piece to give it a clean look.

Step-by-Step Project

Lettering with Porcelain Pens

PICTURE THIS. You awake on a cold, rainy morning and curl up with a blanket and a warm cup of coffee. As you settle in to enjoy your cup of caffeinated goodness, you look at the cup and smile. On the cup, in all its hand-lettered beauty, is the phrase, "Hello, beautiful." Now, despite the rain, your day is off to a good start. This is just one of the cool applications for using porcelain pens on glass or ceramics. You will love the beautiful effects they produce!

► **STEP ONE** Wash and thoroughly dry the plate or mug. Follow the directions on the porcelain pen packaging to get the ink flowing. This usually involves shaking the pen and pressing the tip against a piece of paper until the ink flows down into the tip. Then start lettering! Work from the corner farthest from your dominant hand to avoid smudging.

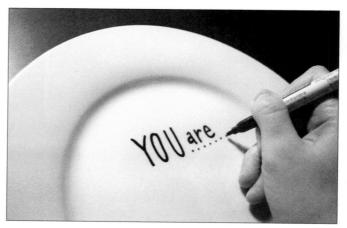

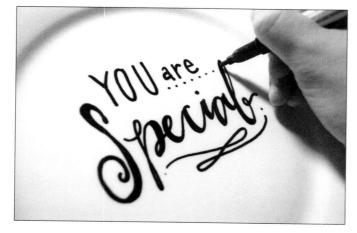

◄ STEP TWO Take your time. Due to the nature of porcelain pens, it's important to work carefully and accurately. It is nearly impossible to correct mistakes, as these pens use oil-based ink that will stain and smear if you try to wipe it off.

88

► **STEP THREE** Make sure your lettering work is completely dry before adding illustrative touches to complete the design.

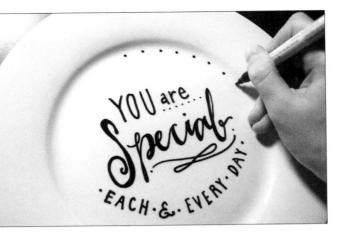

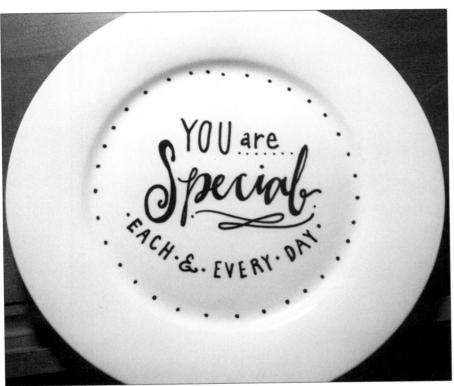

◄ STEP FOUR Follow the directions on the pen's packaging to allow for proper drying time and for baking to make your work permanent.

> Practice your lettering on a piece of paper before you begin drawing with the porcelain pen.

Other Examples ownje ELLO EVERYONE ELSE ... is taken.

Lettering Prompt

Lettening within Lettening

THIS LETTERING TECHNIQUE is fantastic for fun, quirky works of art! Try using it to create customized stationery or wall art.

STEP ONE

Choose a word for the background, and sketch it out in big block letters. Fill in the letters.

STEP TWO Pick

a quote, phrase, or series of words, and use a different colored ink (dark ink for light backgrounds and white or other light ink for dark backgrounds) to add the lettering!

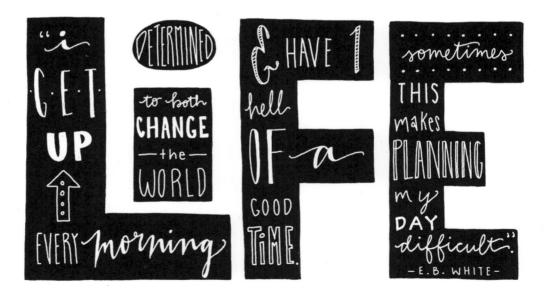

Stippling Lettening

STIPPLING IS A TECHNIQUE that involves drawing or painting small dots to create detail and depth. I love to use stippling as a technique for pen-and-ink drawing, but it is just as fun to use in hand lettering for a really cool effect.

Lettening Exercise

STEP ONE Trace or sketch the outlines of your letters.

► **STEP TWO** Begin to stipple. Stippling can be a long process, so choose a pen that has lots of ink left in it. I like to start at the top with more dots closer together and fewer dots further and further apart as I work down to create an ombré look. Make sure that the dots at the bottom are still numerous enough to maintain the integrity of the letter's outline.

◄ STEP THREE Apply the stippling technique to the rest of the letters. Step back and survey your work from a distance to see if there are any inconsistencies in the stippling gradient. Add more dots as needed, and then erase your pencil lines.

Love stippling? Try it in reverse to create a cool negative effect!

◄ STEP ONE Choose a quote, and sketch the outlines of the letters. For this technique, I find it easiest to draw an outline of a shape around the letters, such as a circle.

► **STEP TWO** Start stippling, but this time stipple only in the background—around the letters, not in them. You can stipple in a gradient or ombré, or in any number of patterns. For example, you could draw stripes and stipple some stripes darker than others.

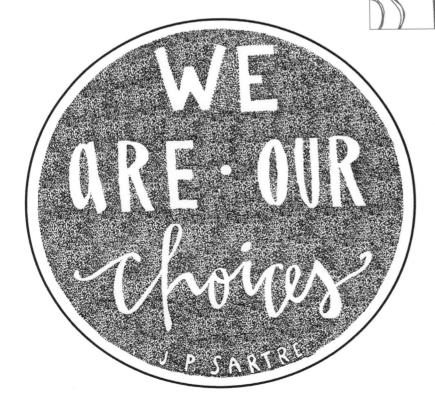

◄ STEP THREE Once you are done stippling, erase the pencil marks! Add any other decorative details at this time. I added another circle to frame the design.

Chalk Lettering

WITH SHAUNA LYNN PANCZYSZYN

GET EXCITED! In this section we are going to explore hand lettering with chalk. Chalk lettering has gained popularity in recent years in print work and especially for weddings. It harkens back to a time when things were tactile and crafted with love.

There are two ways to create chalk lettering. One way is traditional, with real chalk and chalkboards. The other way is digital. I cover both mediums in this chapter and show you how to create your own masterpieces, whether for your home, a friend, a party, a wedding, or anything beyond!

For chalk lettering, you only need a few tools to get started. A board, chalk, and a damp towel are the basic necessities, which makes this art form easy and approachable. It also makes it very versatile and fun, since chalk isn't a permanent medium.

> So, let's dust off those boards and get lettering!

Chalk Lettening Tools

IT DOESN'T TAKE MUCH to create beautiful chalk lettering and artwork. All you truly need is a chalkboard and a piece of chalk! There are, however, a few more tools you might find helpful as you dive into this fun art form.

Chalkboard

A 16" x 20" chalkboard is a good, manageable size for chalklettering practice and artwork. You can find chalkboards at some art & craft stores and online retailers. You can also make your own chalkboards (see pages 104-105).

Chalk

You don't need fancy chalk—the kind you find in the school-supplies aisle will do the trick! Try to find anti-dust chalk, which creates less of a mess. You'll need plenty of white chalk, but consider investing in a package of colored chalk as well for embellishing your artwork with bursts of color.

Charcoal Pencil A white charcoal pencil is perfect for detail work and fine lines.

Eraser

One of the best things about chalk lettering is the ability to erase mistakes—or almost instantly have a clean slate on which to work! There are myriad erasers available for chalkboards. Choose the kind you prefer to work with.

Cloths

You can also erase chalk from your board with a damp cloth. Keep a stash of microfiber cloths on hand for erasing and cleaning up small areas of the board between and around letters.

Sharpener

You can sharpen chalk with a large pencil sharpener (or even an eyeliner sharpener). The larger opening is just the right size for a piece of chalk. Sharpening your chalk will allow you to be more precise when creating detailed designs.

Soft pastels are another way to bring vivid color to your chalkboard art. Soft pastels are available in sticks or as pencils, with a protective coating to keep your fingers clean. If you decide to experiment with pastels, just be sure to use soft pastels not oil pastels.

Soft Pastels

Lettering Priompt

Hello, My Name Is

PRACTICE LETTERING YOUR NAME in contrasting styles. Search books, magazines, and websites like Pinterest to find contrasting lettering styles (e.g. blackletter, script, and retro). Draw your name in each style. Notice how each style varies from the others, and incorporate those differences into your piece.

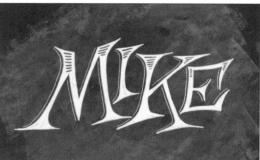

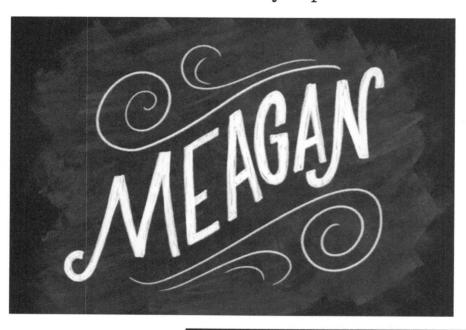

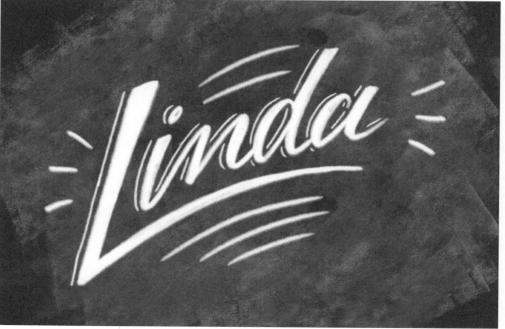

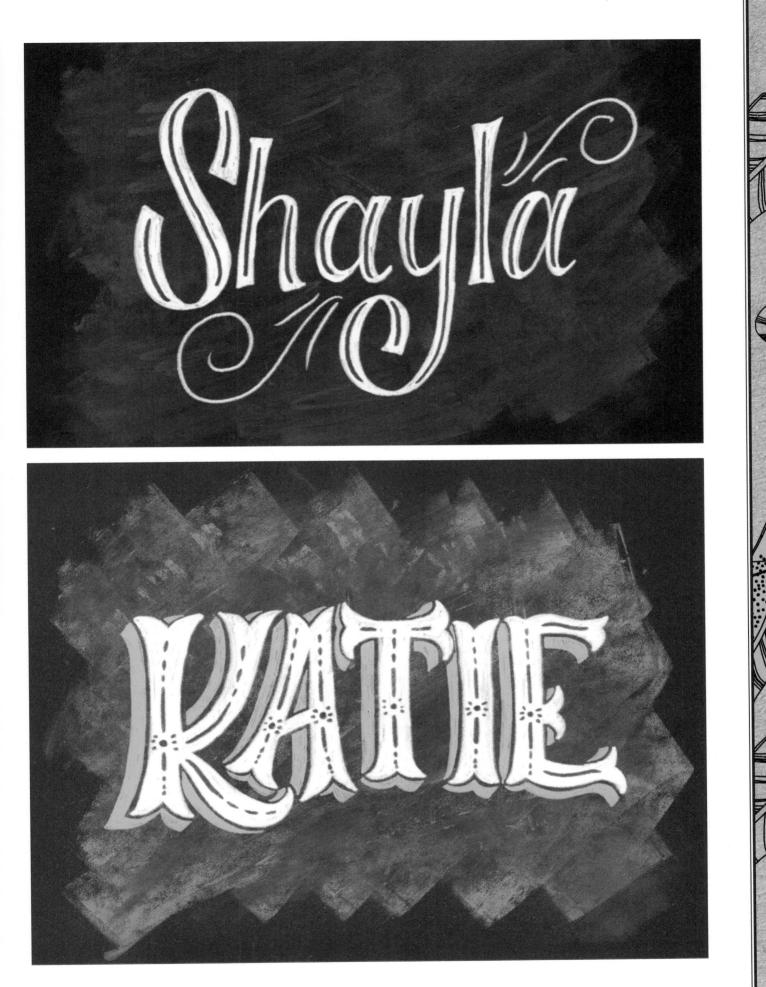

Lettering Priompt

Drop Caps

DROP CAPS ARE THE LARGE LETTERS often found at the beginning of a book chapter. Traditional drop caps are ornate and flourished. However, modern drop caps can be stylized any way you like, as long as the letter is recognizable. Take the first letter of your first or last name—or your favorite letter (I enjoy drawing Q's)—and create your own personal drop cap. Get as ornate as you like, and reference other styles for inspiration!

Drop Cap Examples

Need some inspiration to get started? Try practicing these letters to get your chalk moving and creative juices flowing!

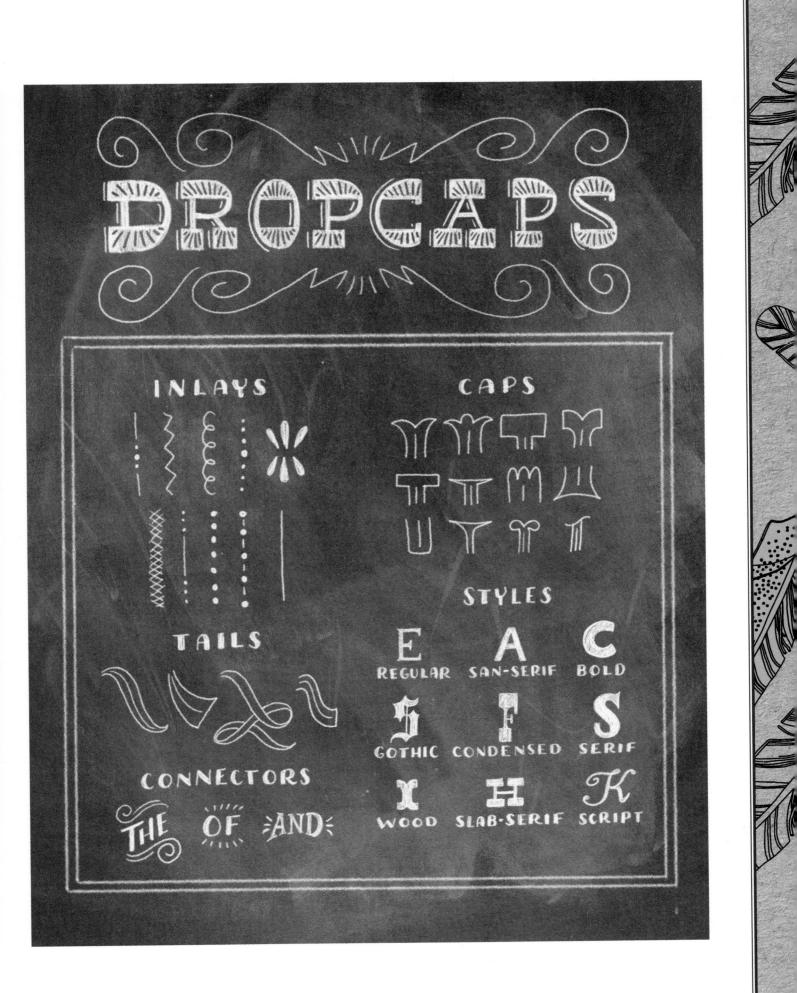

Step-by-Step Project

DIY Chalkboard

IN MY HUNT FOR GOOD CHALKBOARDS, I have found that they're becoming increasingly difficult to find. In this tutorial, I'll show you how to create your own out of just about anything!

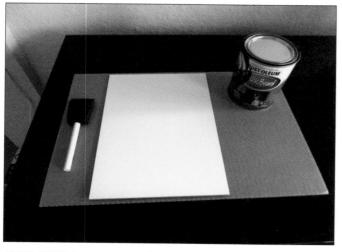

STEP ONE Prep your workspace on newspaper or a large piece of cardboard.

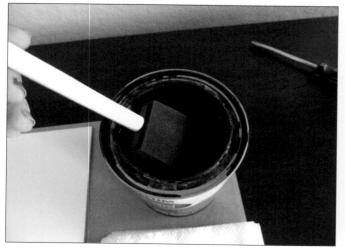

STEP TWO Stir the chalkboard paint until it is thoroughly mixed. If you are painting on plywood or glass, mix your primer first and use the foam brush to apply it to the whole surface. Let dry before moving on. If your surface is already primed, proceed to step 3.

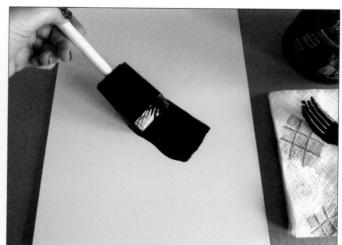

STEP THREE Use the foam brush to apply chalkboard paint to the surface of your board.

Materials

Chalkboard paint (available at hardware stores)

Paint primer (Optional: only necessary for plywood or other unprimed surface)

Sandpaper, coarse and fine

Chalk

Towel or small rag

Foam brush

Clayboard*

*Note: Other hard surfaces also work, but I prefer clayboard because it's solid and smooth.

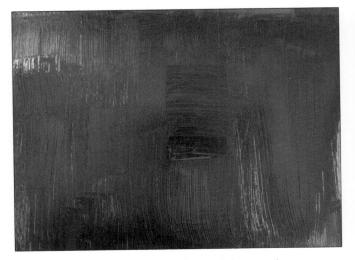

STEP FOUR Let the first coat dry, and then apply another coat.

STEP FIVE Once dry, smooth the surface of your new chalkboard with coarse sandpaper, followed by fine sandpaper to eliminate any bumps the brush may have left behind. This also helps prime the surface for use!

STEP SIX Wipe the chalkboard with a damp cloth to remove the dust. Your new chalkboard is ready to use!

Banners & Borders

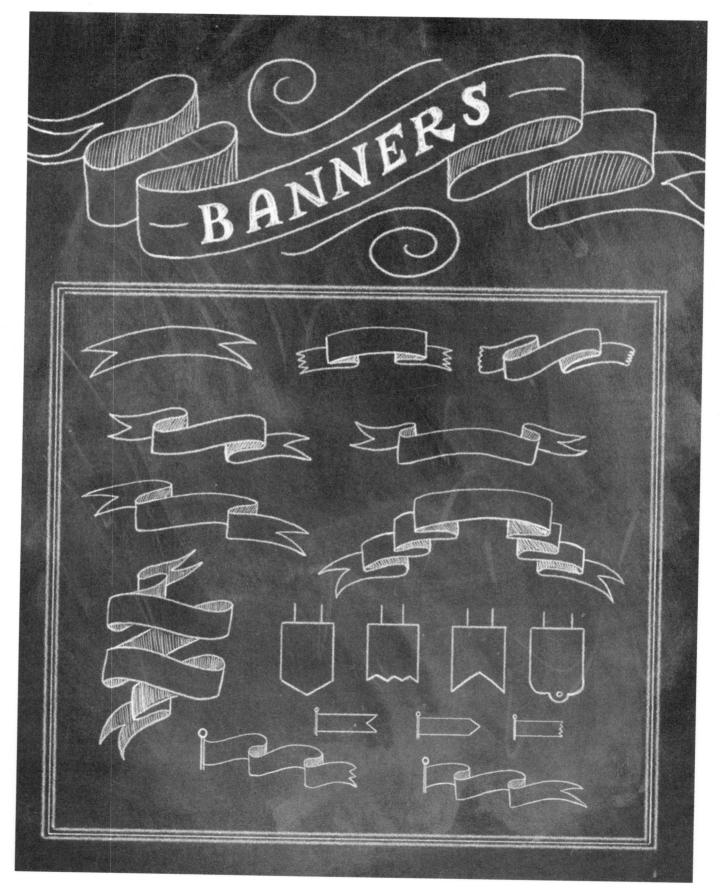

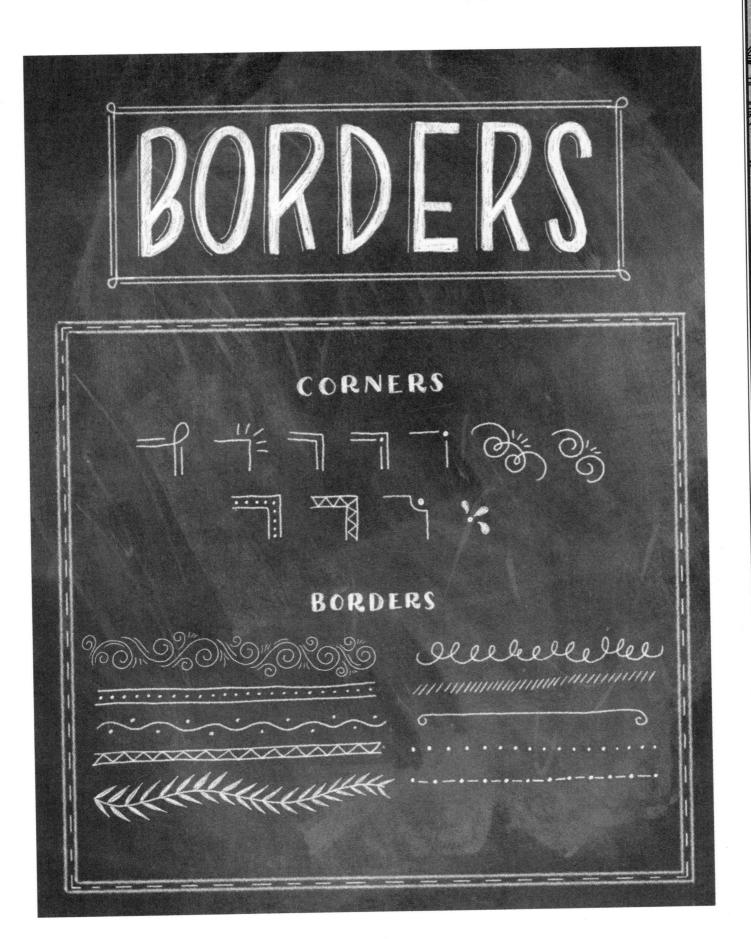

Lettering Priompt

Accessorize & Decorate

Now THAT YOU HAVE A BRAND-NEW, blank chalkboard, just imagine all of the creative possibilities! A chalkboard can be used just about anywhere for just about anything. The sky is the limit!

Create a to-do list board for your office or a menu board for your kitchen. Pick some fun phrases, and have fun lettering them. Don't forget to add simple embellishments for extra pizzazz!

Labels

Everything in our world is labeled: coffee cans, wine bottles, even office supplies! Design a label to fit on a can or in a book. I've created a coffee can label and a book sticker as examples.

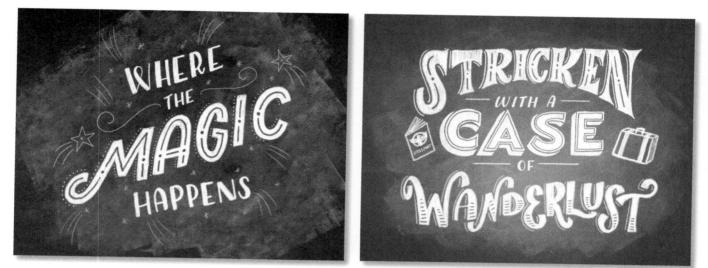

Art Above My Couch

Create a lettered piece of art from a phrase or song you love to hang in your living room. The phrase can be anything that brings a smile to your face.

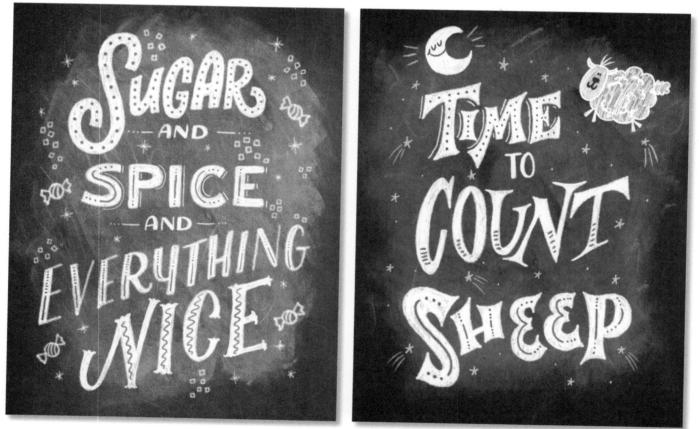

Children's Room Poster

Kids need art too! Design a chalk poster for a child's room. If you don't have kids of your own, imagine designing a poster for a high-end children's store or for a friend's baby shower. Make it fun, and explore some new styles!

Positive is as Positive Does

There is nothing like staying positive, even in the hardest of times. Take one of your favorite phrases and letter it as a motivational poster. Keep the work happy and bright!

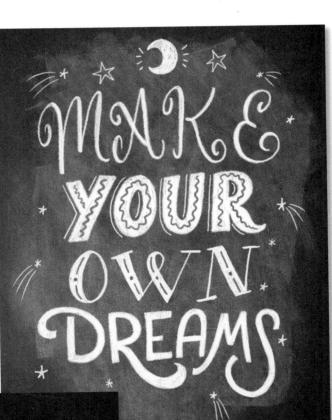

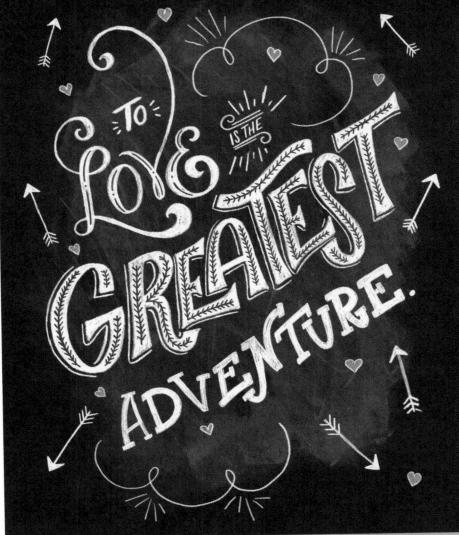

Chalkboard paint is available in myriad colors, not just black. Try creating a teal, pink, or purple chalkboard!

111

Step-by-Step Project

Kitschy Kitchen

DESIGN A FUN AND KITSCHY CHALKBOARD work of art for your kitchen! You can use anything, from a silly phrase to a recipe to a simple illustration.

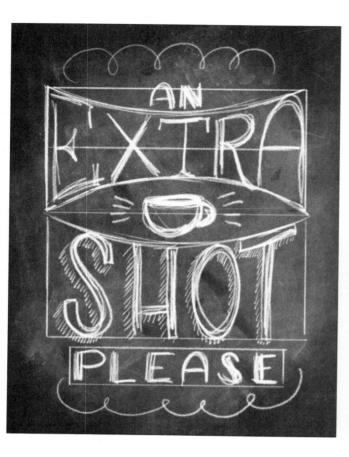

► **STEP TWO** Block in the letterforms. Look at various items or advertisements for font styles and treatment. I like to draw inspiration from vintage labels—in this case, coffee labels. Experiment with the style of the lettering until you are happy with the look.

◄ STEP ONE Brainstorm ideas and phrases for your kitschy kitchen art. Since I am a coffee lover, I chose the phrase, "An extra shot please." Sketch some different layouts, and pick the one you like the best. Then roughly sketch it on your blank board. Don't be afraid to make mistakes—that's what your wet cloth is for!

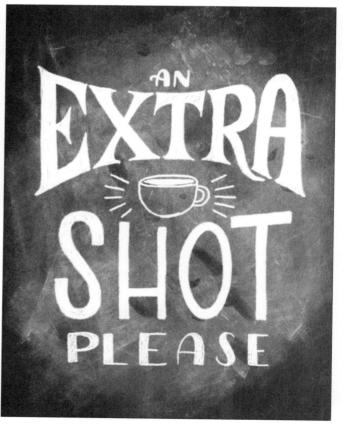

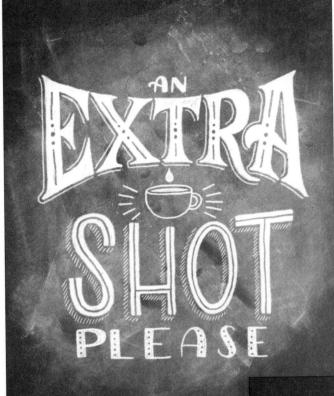

▲ **STEP THREE** Now it's time to add details to your lettering. I added a simple line shadow to "Extra" and another shadow detail to "Shot." I also added some inline details (inside the letters) for an extra punch.

► **STEP FOUR** Finalize your piece by cleaning up your letters, removing any stray marks, and adding in flourishes and extra details. Display your new illustration proudly for all to see!

Simple lines can add a great deal of depth and dimension to your letters. Notice how both a solid line and a series of dashed lines make the letters appear to pop out from the board.

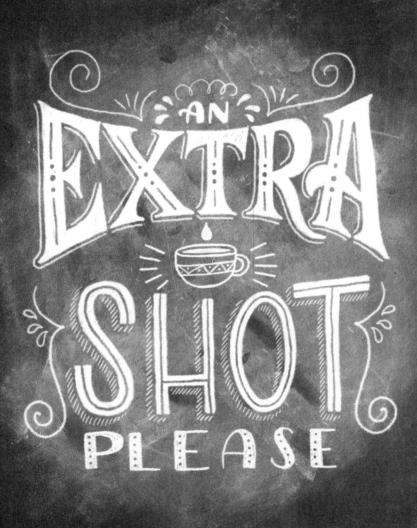

Step-by-Step Prioject

Digital Chalk

WITH THE HELP OF PRE-DESIGNED "brushes" and digital backgrounds, it's easy to use digital imaging software, such as Photoshop, to create digital chalk artwork!

Materials

Photo-editing software Digital drawing tablet Chalk dust brush* Digital chalkboard backgrounds* "Chalk" or pencil brush*

*You can purchase brushes and backgrounds to use in chalkboard and illustrative artwork from various online platforms. Just use your search engine!

STEP ONE Open a new document (CMYK) in Photoshop (I use standard 8.5" x 11"), and create a new layer. Copy and paste in a chalkboard background, and fit to the size of the document.

Digital Drawing Tablet

A digital drawing tablet allows you to digitally capture what you draw by hand on the tablet, using the accompanying wireless stylus. This stylus offers precision and control that cannot be obtained with a mouse. The stylus is also pressure-sensitive, which means you can apply more or less pressure to create thick or thin lines just like traditional tools! While digital drawing tablets can be expensive, certain models are geared for beginning artists and hobbyists and are more affordable.

Τμρ
 You can adjust your tools

 to your liking in the
 Brush Presets palette.
 I slightly adjusted the
 levels of the brushes
 from a purchased set
 to achieve a rougher,
 sketchier feel.

STEP TWO Create a new layer for the "dust." Select the brush tool and your chalk dust brush. Enlarge the brush to the desired size, and click once on the board.

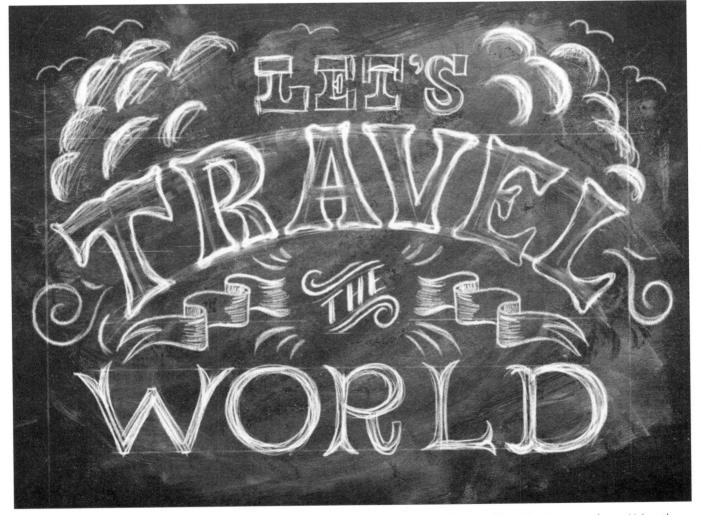

STEP THREE Select a pencil brush from your Tool Presets palette, and set the color to white. Create a new layer. Using the tablet and pen, begin sketching the lettering and other elements. I like to create a new layer for each word.

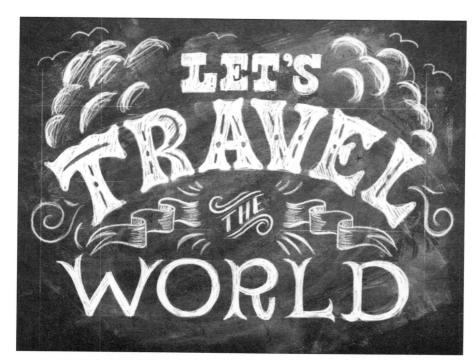

STEP FOUR Once the lettering is blocked in, fill in the letters and adjust them as needed. I erased some of my guidelines and added rough details. Then I added minor details to the lettering to see how they fit within the overall piece.

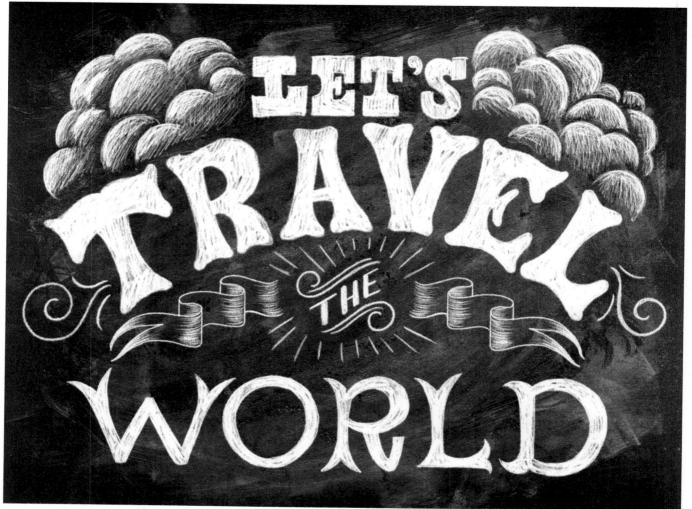

STEP FIVE Redraw, refine, and adjust your letters. I wanted my lettering to pop more against the background, so I switched the dusty, gray chalkboard background for a darker, cleaner background. I adjusted the details on the letters so they look more polished. Take your time on this step. This is where most of the work happens. Pay attention and make sure the letters match in style and size.

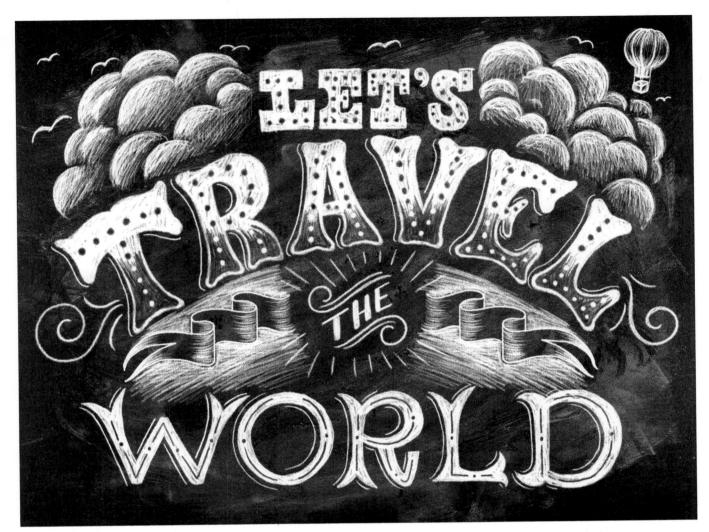

STEP SIX Finalize the piece by adding detail to the lettering. I added gradients and dots on "Travel" with the eraser tool to make it stand out. Continue playing with your lettering until you are happy with it. Then add other details and embellishments, such as a hot air balloon and birds.

If you plan to post your new digital art online, be sure to change your settings to RGB or use the "save for web" option in Photoshop. If you plan to print your finished masterpiece, make sure you print from the CMYK version you started with.

Lettening Priompt

Greeting Cards

NOTHING SAYS THOUGHTFUL like a homemade greeting card. Dazzle your friends and family by creating your own personalized greeting cards for any and all occasions! I created a congratulations card, because there's always something to celebrate!

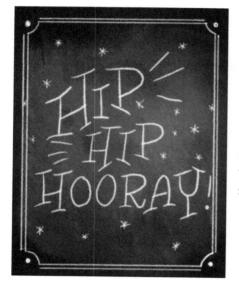

STEP ONE I played with 60s-style lettering in my initial sketch, using some fun and playful serifs.

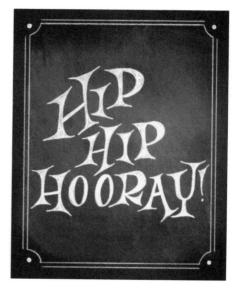

STEP TWO

I started adding the serifs to get a rough idea of where they will go, but they need some refinement.

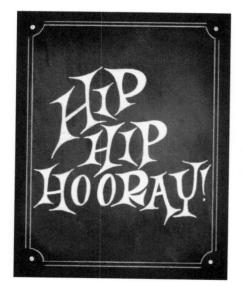

STEP THREE I adjusted some of the letters and changed their look just slightly.

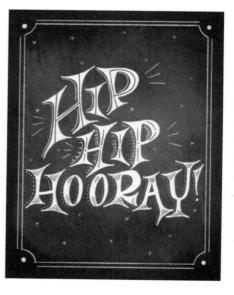

STEP FOUR

I added little starbursts around my lettering to match the celebratory nature of the card.

Creating the Card

There are three ways to create the actual card once you have finalized the design.

- Put your digital chalk skills to work, and recreate the card digitally! (See pages 116-119.)
- Photograph the finished design, and upload to your computer to size and print.
- If you prefer to work hands-on, use black cardstock or chalkboard paper and a chalk marker to replicate your final design.

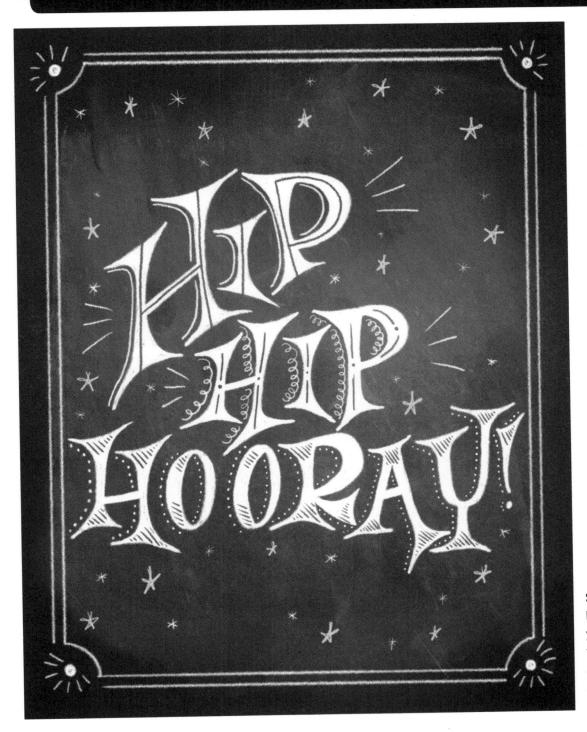

STEP FIVE

I scattered bigger yellow stars around the piece. I also added some bursts around the border elements.

Florals & Filigree

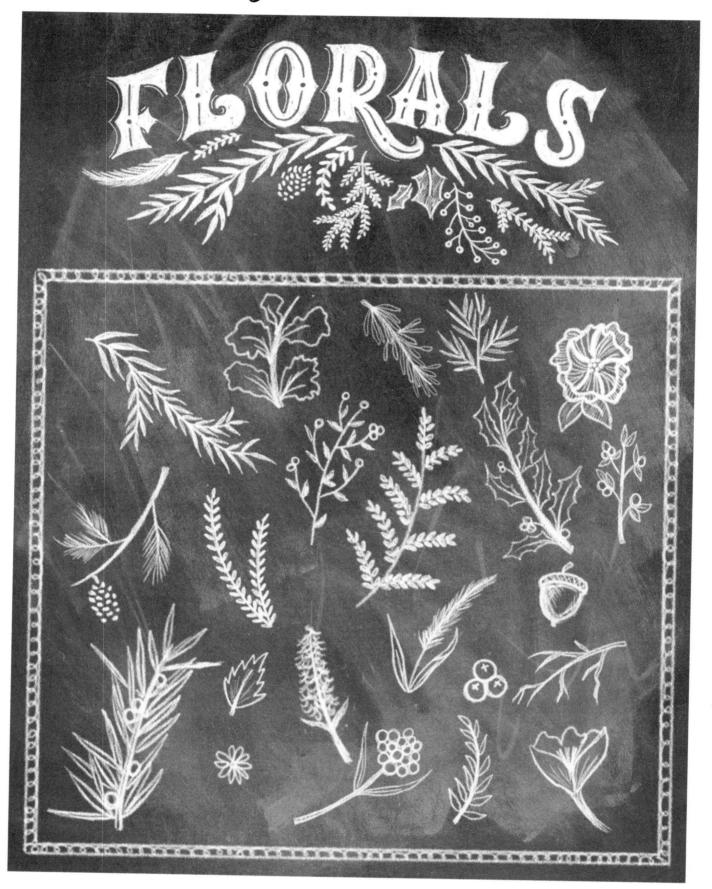

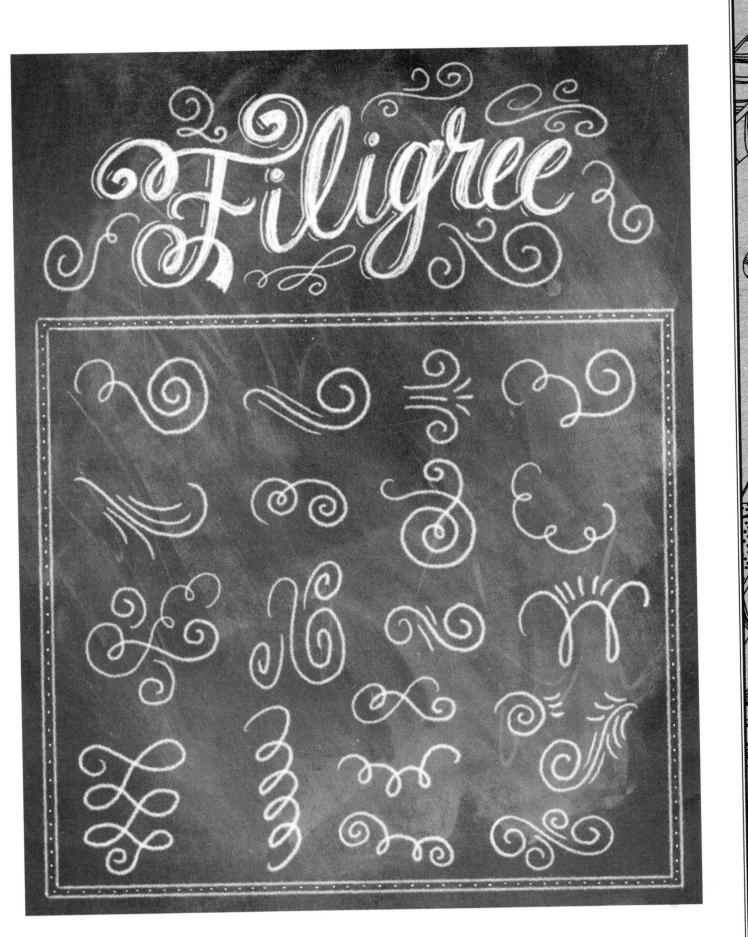

Lettening Exercise

Let's Get Floral

IN THIS EXERCISE, WE'LL EXPERIMENT with chalk realism, as well as creating gradients. I'm drawing floral elements, but you can choose to include anything you like! To get inspiration for flowers and greenery, take a look at some Victorian references and seed packets.

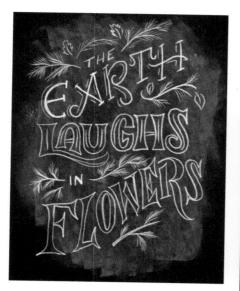

STEP ONE After looking at some reference images for inspiration, lay out a rough sketch on your blank board.

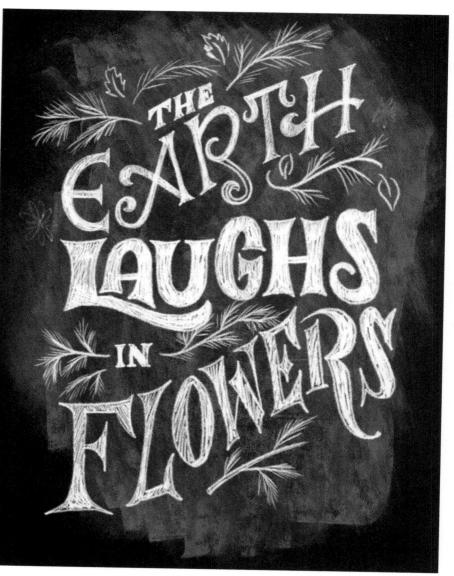

STEP TWO Next block in the letterforms and work on defining the style of the entire piece. To keep the piece feeling Victorian, I kept my letterforms in a serif style and added curves.

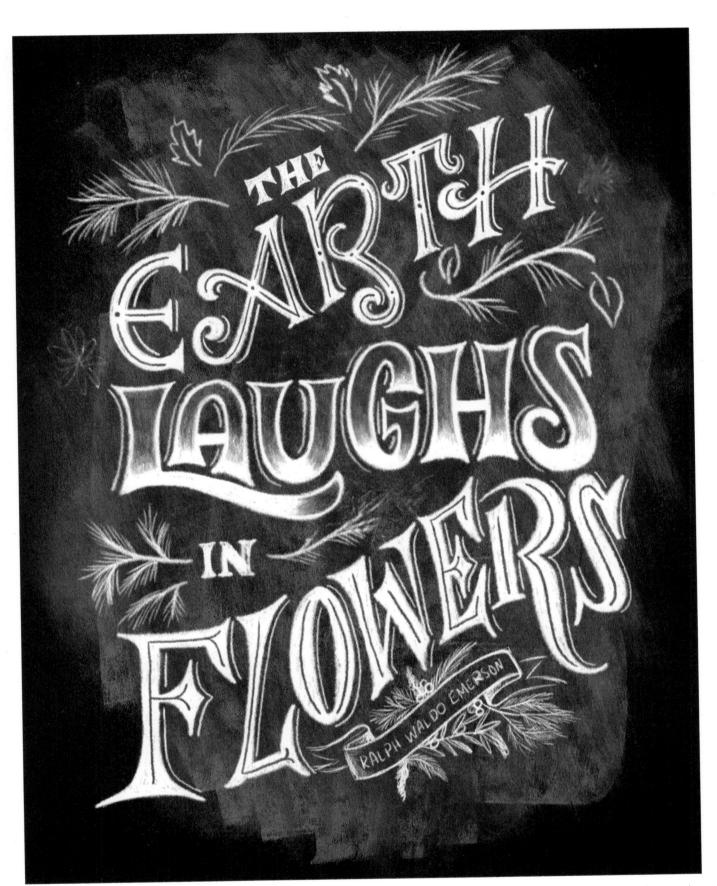

STEP THREE Time to add detail to the lettering. I had a lot of fun in this step by experimenting with gradients in the word "laughs"—something I'd never done before! To achieve a gradient look, wipe away a section of the word and slowly shade in the area with chalk to create a gradual, soft gradient. I also added inline details to "earth" and "flowers" and a line shadow to all the big words. Have fun with this step, and experiment with gradients or other line details!

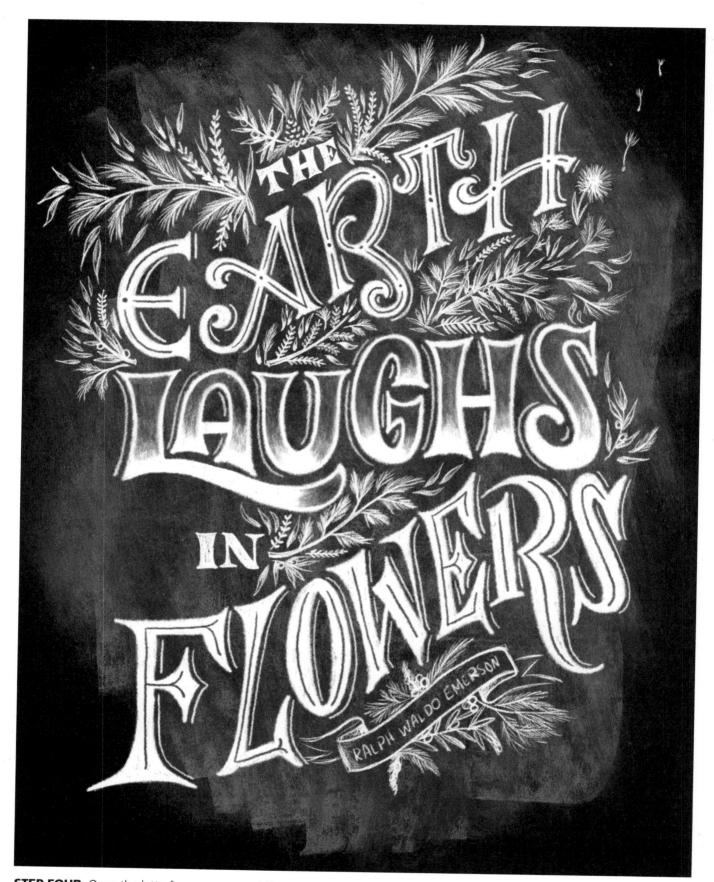

STEP FOUR Once the letterforms are essentially complete, focus on the elements that will tie your piece together. I pulled inspiration from fields of flowers and used various branch and leaf details to highlight the lettering and fill in the negative space. It's very easy to overdo it, so be mindful of what you draw and how much to include.

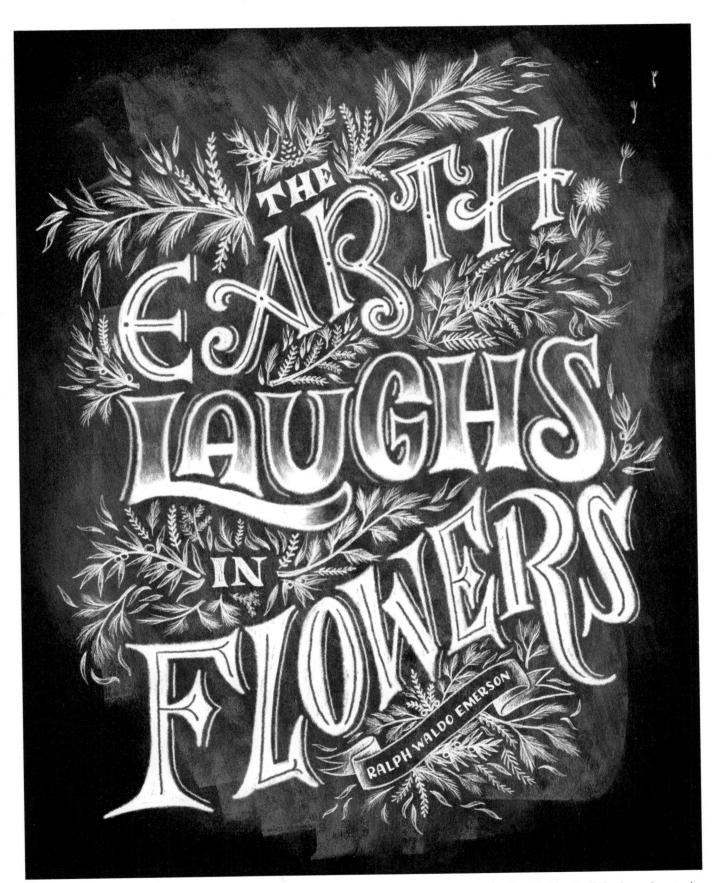

STEP FIVE Finalize your piece by cleaning up any stray marks and adding in any last details. I finished off the branches and added random long leaves to give the illustration some whimsical fancy.

Lettening Exercise

Dreams

SOMETIMES I FEEL LIKE A FIVE-YEAR-OLD trapped in an adult's body—and as such, I love fairy tales and dreaming. For this project, let's dive into our childhood fantasies and create a really whimsical piece.

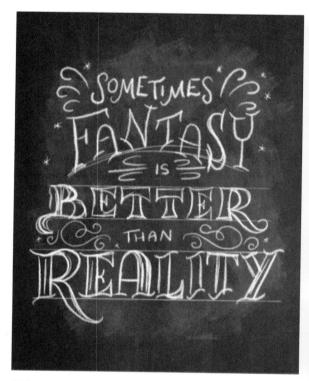

STEP ONE I chose the phrase, "Sometimes fantasy is better than reality." Feel free to come up with your own phrase or use one from your favorite fairy tale! Begin by making a few rough, quick sketches on paper. Then pick your favorite layout, and sketch it onto your board.

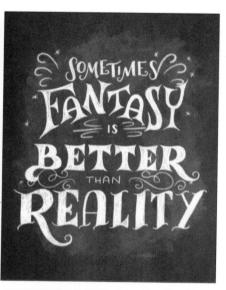

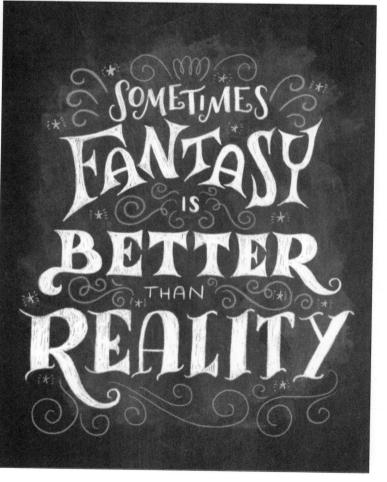

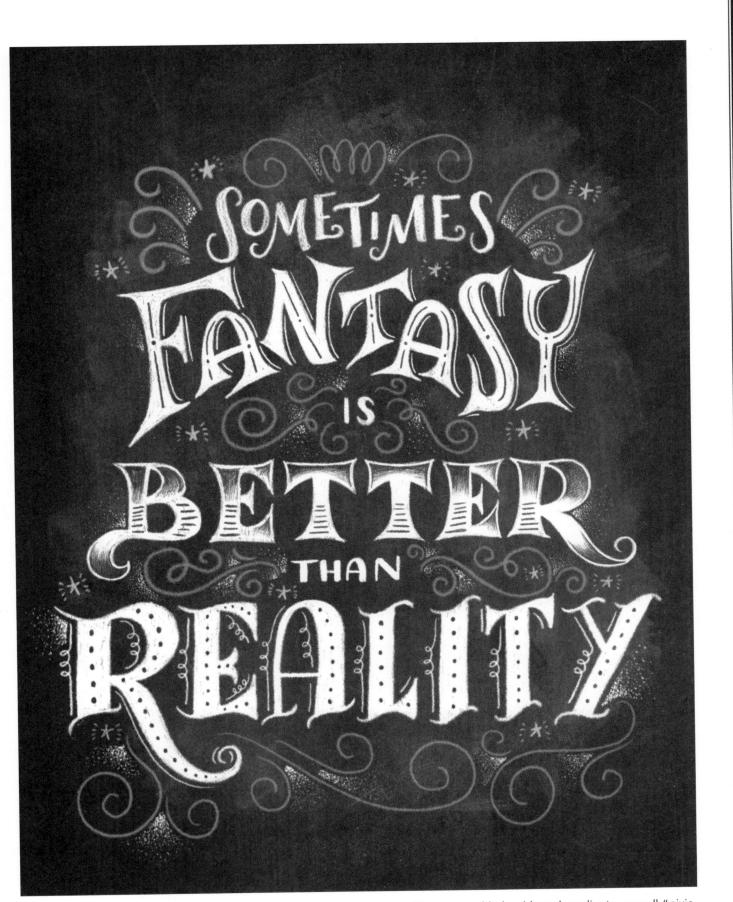

STEP FOUR Start adding details to your lettering. There are no rules in this step! I added swirls and gradients, as well "pixie dust" to the curves and filigree. Just experiment, and have fun! If you add something and it doesn't work, simply erase it and try again.

Lettering Crafts

WITH JULIE MANWARING

STITCH IT, PAINT IT, WOOD-BURN IT—THE CREATIVE APPLICATIONS FOR CALLIGRAPHY AND HAND LETTERING ARE LIMITLESS!

In this chapter we'll look at three different projects that will inspire and breathe new life into your letterforms. By calligraphing onto unique surfaces and using multiple mediums, your lettering can take on a whole new (possibly third) dimension! We'll explore whimsical ways to personalize a gift, add charm to your tablescape, and jazz up your next cocktail party.

Let's combine your penchant for the handmade with your love of lettering, so raid that craft closet and start creating!

Step-by-Step Project

Gift Tags

WITH A SIMPLE GIFT TAG CRAFT PUNCH, you can create limitless beautiful gift tags for any occasion or holiday. In this project, I demonstrate three creative ways to personalize a gift using calligraphy. I recommend purchasing a craft punch for gift tags, but you can still make these fun tags by creating your own template and tracing and cutting the tags individually.

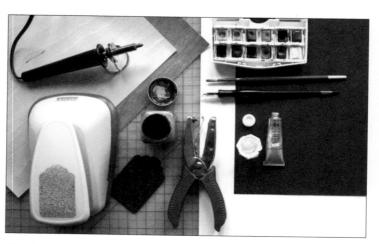

All of these materials are available at art & craft stores or can be purchased online. For each type of gift tag, you will need a gift tag craft punch and a hole punch.

While a gift tag craft punch is not absolutely necessary, they are quite affordable and perfect for quickly generating multiple tags. They also cut more cleanly through thicker papers such as card stock.

Tip

Materials

WATERCOLOR GIFT TAG

Watercolor paints & paintbrush Watercolor paper Black ink Calligraphy pen & nib Ribbon Gift wrap

BLACK & WHITE BOUQUET TAG

Black card stock White gouache Ink holder (e.g. dappen dish) Calligraphy pen & nib Raffia

WOOD-BURNED HOSTESS GIFT TAG

Wood paper Electric, wood-burning craft tool Twine

Watercolon Gift Tags

Create colorful, whimsical tags using a watercolor wash and coordinating ribbon—perfect for gift-wrapping!

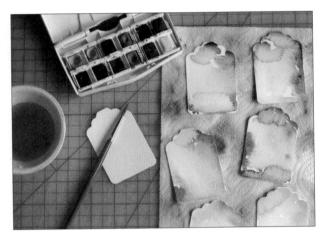

◄ STEP ONE Punch or cut gift tags from watercolor paper. Then create a watercolor wash on each tag by loosely brushing paint over the paper. To create marbled swirls and avoid an overly pigmented tag, apply plenty of water to the paper as you work.

Pairing tags with coordinating ribbon makes each gift unique and allows you to further personalize the gift by using the

recipient's favorite colors.

STEP TWO

Allow the paint to dry completely. Then, using black ink, add the name of the gift's recipient in calligraphy over the watercolor wash.

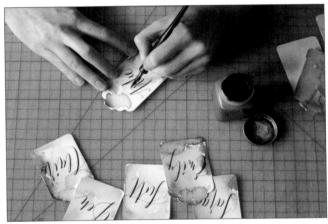

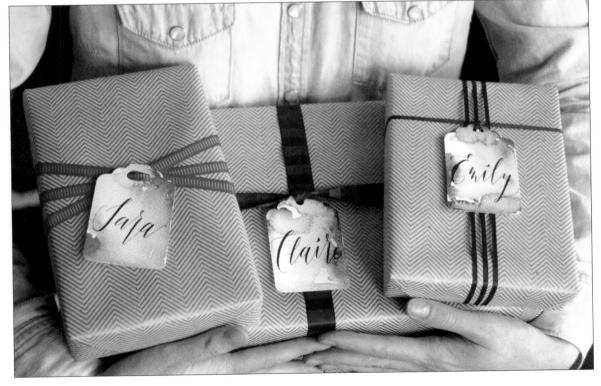

STEP THREE

Punch a hole in the tag, and feed ribbon through it. Wrap your gift, and adorn it with the personalized tag and ribbon.

Wood-Burned Hostess Gift Tag

Using a wood-burning tool creates a bold and impressive wooden tag—a unique way to dress up a hostess gift!

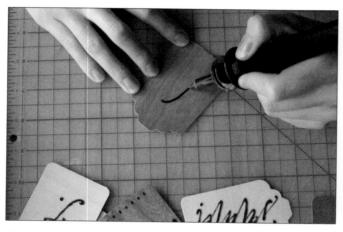

STEP ONE Punch gift tags out of wood paper. Then prepare a safe, clear area to work with the wood-burning tool. Plug it in and allow it to fully heat. Begin working on the tags, firmly applying the wood-burning tool to the paper and using it like a pen to letter the words.

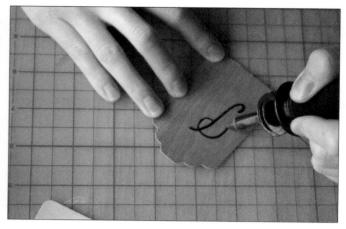

STEP TWO Continue working on the tags by returning to areas to create a deeper impression, adding thicker line weights, or embellishing with flourishes and design details.

These versatile tags can be used for just about anything! If you're worried about spacing and alignment, try penciling in your word or design first and burning over the pencil lines.

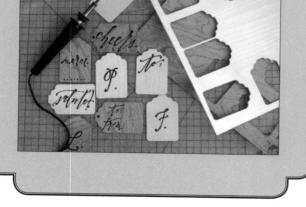

STEP THREE Punch a hole in the tag, feed twine through it, and attach the tag to your hostess gift. I chose a wine bottle and wrapped the twine around the bottleneck before tying it off in the back.

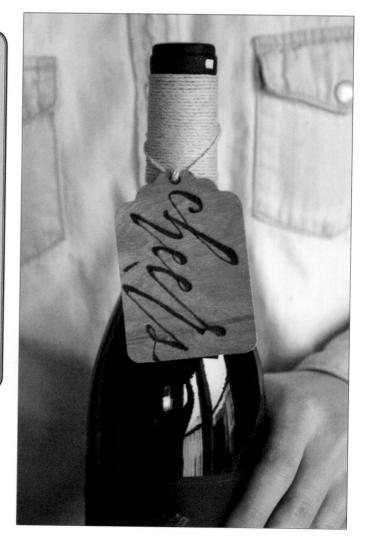

Black & White Bouquet Tag

Add simple elegance to a black tag by using white lettering. Wrap it around a bouquet of flowers for a romantic touch.

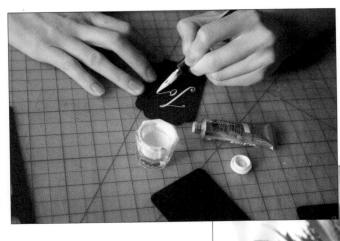

STEP ONE After punching out gift tags from black card stock, mix a dollop of white gouache with water in a dappen dish or other small ink holder, creating a consistency like heavy cream—thin enough to flow through the nib, but thick enough to maintain its opacity on the black card stock. Dip the nib into the paint, and letter on the card stock.

► **STEP THREE** Allow the paint to dry completely. Then punch a hole in the tag and use raffia to attach it to a beautiful bouquet of flowers.

or J.

Step-by-Step Project

Calligraphed Place Settings

USING KRAFT PAPER AS A TABLECLOTH, create a whimsical and fun alternative to boring ol' place cards. Unique, beautiful, and cheap, try this out the next time you host a party or gathering!

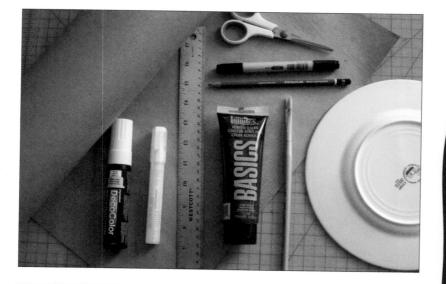

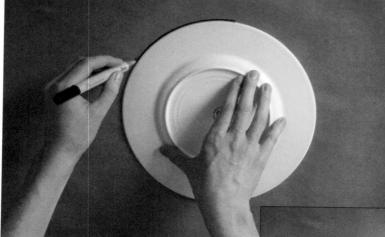

Kraft paper* Pencil Ruler Scissors Paintbrush Black acrylic paint Black marker White fine-point paint marker White broad-point paint marker Dinner plate

Note: Select the width of your kraft paper according to your table's dimensions and your chosen design (e.g. full tablecloth or runner).

▲ **STEP ONE** Unroll the kraft paper and cut to your desired length. Map the location of each place setting, and measure and mark where the plate will sit. Then, using a dinner plate as a template, trace the circle in black marker at each place setting.

STEP TWO Carefully paint the circle with black acrylic paint, and allow the paint to dry completely.

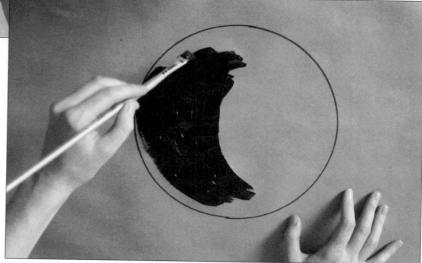

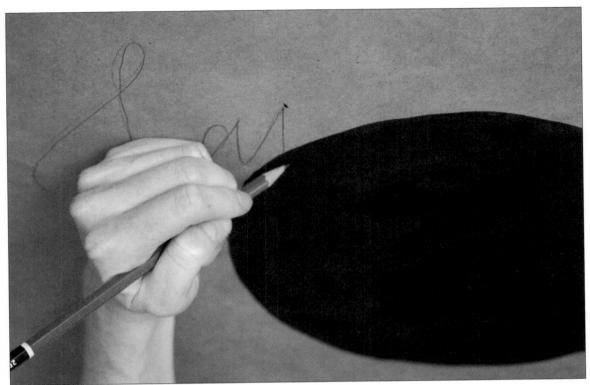

STEP THREE

Using a soft pencil (such as a 2B), lightly draw in the name of a guest above each painted circle.

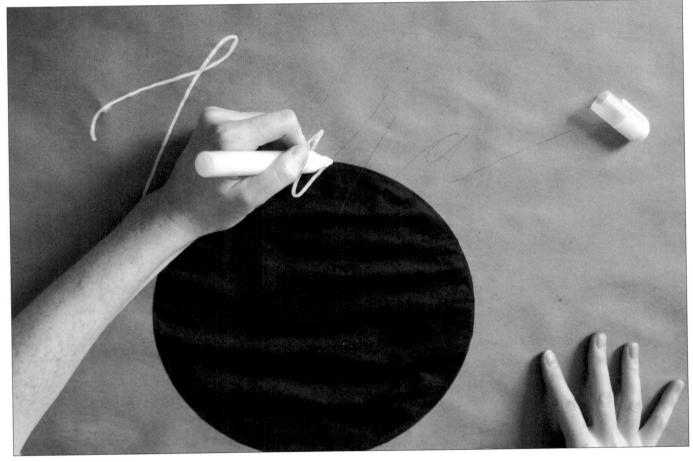

STEP FOUR Use a white fine-point paint marker to trace over the pencil lines.

Determine the placement of each downward stroke by looking at the letter and noting each place where you would pull your pen down if you were using a traditional calligraphy pen and nib.

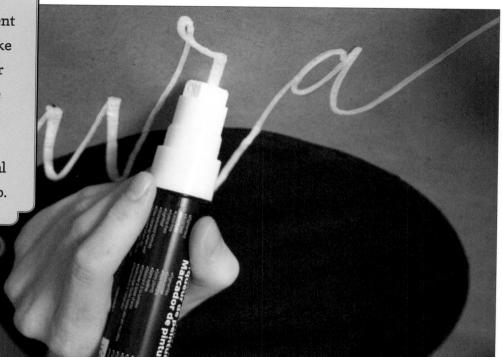

STEP FIVE To create a calligraphy look, use a white broad-point paint marker to go over each letter's downward stroke to make a thicker line weight.

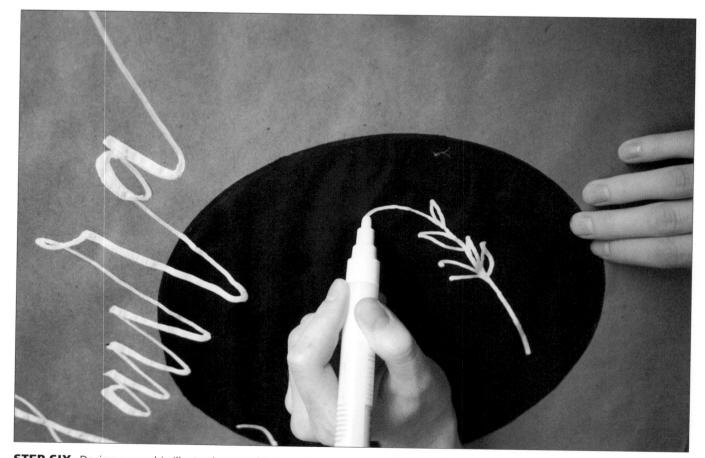

STEP SIX Design a graphic illustration or whimsical flourish, and add it to each painted plate with a white paint marker.

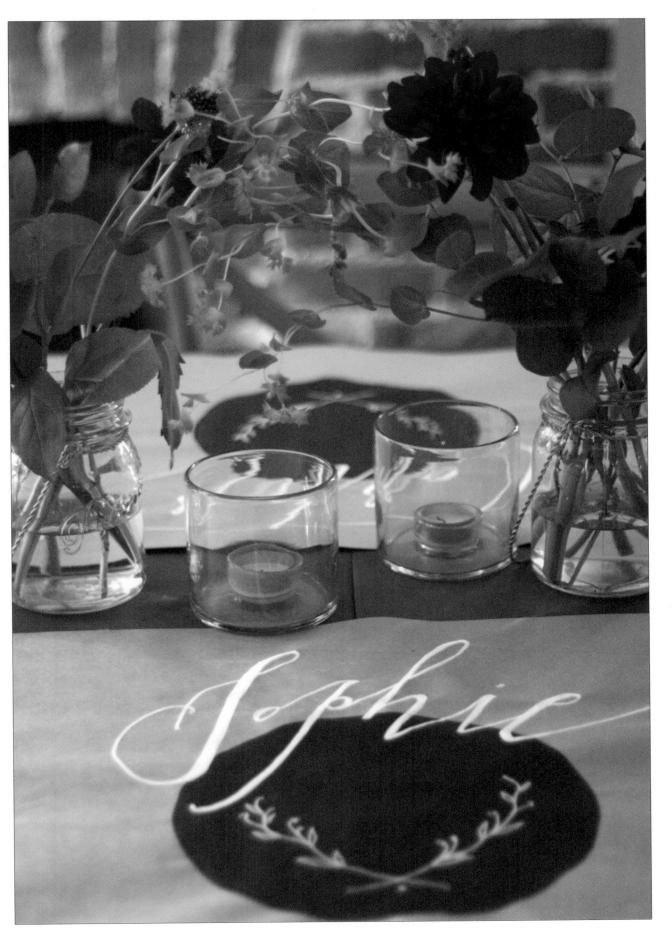

Monogrammed Cocktail Napkins

DITCH THE KITSCHY PLASTIC WINE CHARMS for your next party, and stitch up monogrammed cocktail napkins—a beautiful, classy way for guests to tell whose glass of red is whose, while keeping hors d'oeuvres in place and fingers clean! Using a basic embroidery split stitch, these personalized napkins also double as elegant party favors.

Step-by-Step Project

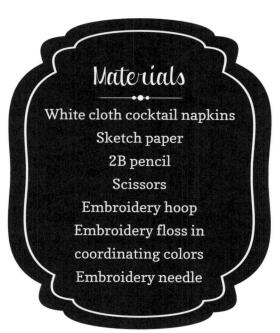

▼ **STEP ONE** Sketch out a monogram for each guest on drawing paper. You can make the monograms all the same or try to personalize them based on the guest. It's up to you!

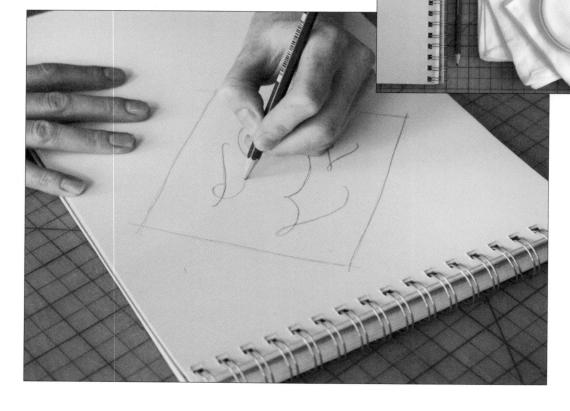

► **STEP TWO** Place a napkin over the monogram, and use a soft 2B pencil to lightly trace the monogram onto the napkin.

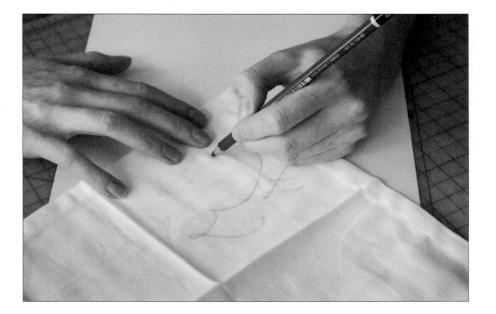

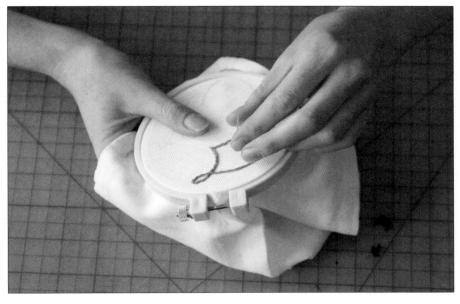

✓ STEP THREE Drape the napkin over the bottom section of the embroidery hoop (the piece that has a lip), and place the top section of the hoop (the piece with the nut and bolt) over it, pushing down. With the fabric sandwiched between the two pieces, pull the napkin taut as you tighten the screw to secure it in place. Then feed the embroidery floss through the needle, and tie a knot at the end. Begin stitching along your sketch, using a split stitch (see "How to Split Stitch").

How to Split Stitch

Create the first stitch by pulling the needle up from the back of the fabric through the starting point of your letterform. Follow along the penciled line ¼" before pushing the needle back through the fabric to complete. To make the second stitch, bring the needle up through the center of the first stitch (A). Then follow the penciled line ¼" before pushing the needle back down again (B).

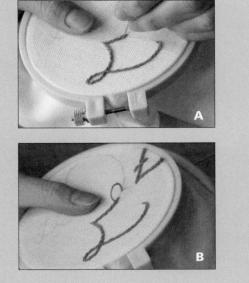

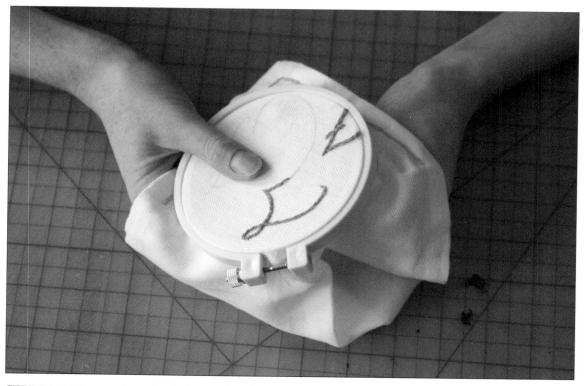

STEP FOUR Repeat the split stitch, carefully following your penciled letterform. After the final stitch, tie off the embroidery floss on the bottom side of the napkin and trim the tail. Repeat the process with the remaining napkins.

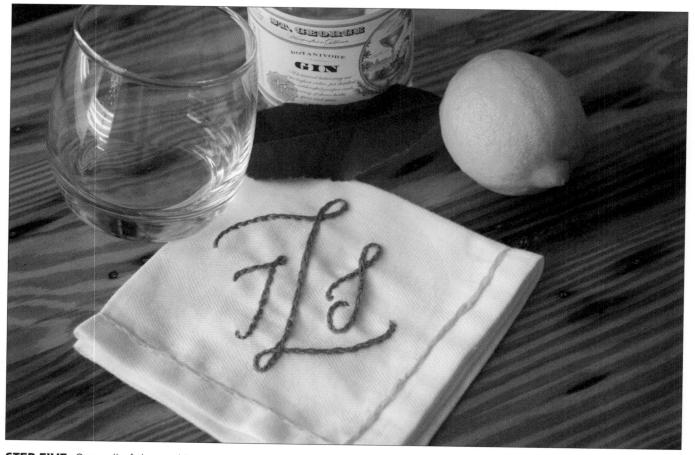

STEP FIVE Once all of the napkins are monogrammed, use the same stitching technique with a second floss color to create a border by stitching along the napkin's hemline.

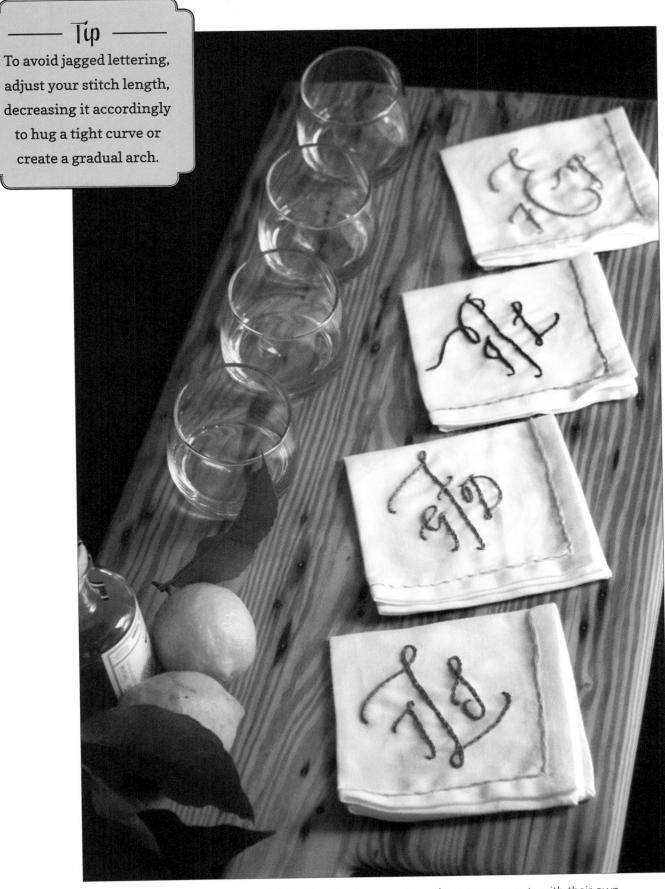

STEP SIX Iron out any napkin wrinkles. Then host your party and wow your guests with their own personalized cocktail napkins!

About the Artists

GABRI JOY KIRKENDALL is a self-taught artist and the creator behind Gabri Joy Studios. She specializes in hand lettering, but she also works with pen and ink, watercolor, and mixed media. Her art graces homes not only in the Pacific Northwest, where she lives and works, but also has traveled around the world to clients and fellow enthusiasts in far-flung climes such as England, Spain, Canada, New Zealand, and Australia. Gabri's work has also been featured and sold by companies such as Threadless and in local art galleries. She finds joy in volunteering her time as an independent business consultant helping others fulfill their dreams of entrepreneurship. To learn more about Gabri and her current projects, visit www.gabrijoystudios.com.

LAURA LAVENDER has always been passionate about the fabulous world of the arts. She earned a BA in Fine Art and has had the privilege of studying calligraphy with many fine teachers. Her work has been commissioned by greeting card and book publishers, fashion designers, and musicians and has been featured in many magazines and blogs. Laura lives on Vancouver Island in Canada, where she paints, sews, gardens, dances and sings, and spends time with her family. To learn more about Laura, visit www.lauralavender.com.

JULIE MANWARING has long loved the whimsical, rhythmic beauty found in the repeating letterforms and flourishes of calligraphy. Her custom hand-lettering and illustration studio, Flourish & Whim, grew out of this love for letters and passion for art. Julie's styles are a unique blend of classic and modern—the perfectly imperfect ups and downs, swirls, and undulations create a graceful dance of words. Hailing from the Northeast, Julie currently lives in San Francisco with her family of three. When not in the studio, she can be found swinging at the playground with her son, strolling through the neighborhood fabric shop, or combining efforts with her husband on a new pizza recipe in the kitchen. To learn more about Julie and her work, visit www.flourishandwhim.com.

SHAUNA LYNN **P**ANCZYSZYN is a hand-lettering artist and illustrator located in Orlando, Florida. After graduating from the University of North Florida with a Bachelor of Arts, she interned at a local advertising agency, where her love of hand lettering and illustration was fostered and encouraged. Now a full-time freelance illustrator, Shauna has an unhealthy obsession with typography and is quick to point out awesome lettering and packaging examples to her friends and family, who thankfully put up with her quirkiness. She loves to create side projects based around lettering, such as her Three Word Stories project and positive quotes. Shauna works out of her home studio with her puppy, Teddy. Learn more about Shauna by visiting www.shaunaparmesan.com.